THE COMPLETE
GUIDE TO...

ANIME

TECHNIQUES

THE COMPLETE GUIDE TO...

ANIME

TECHNIQUES

CREATE MESMERIZING MANGA-STYLE ANIMATION
WITH PENCILS, PAINT, AND PIXELS

Chi Hang Li
Chris Patmore
Hayden Scott-Baron

BARRON'S

A QUARTO BOOK

First edition for North America published
in 2006 by Barron's Educational Series, Inc.

All inquiries should be addressed to:
Barron's Educational Series, Inc.
250 Wireless Boulevard
Hauppauge, NY 11788
http://www.barronseduc.com

Library of Congress Catalog Card Number:
2005927800

ISBN-13: 978-0-7641-3380-0
ISBN-10: 0-7641-3380-2

Conceived, designed, and produced by
Quarto Publishing plc
The Old Brewery
6 Blundell Street
London N7 9BH

QUAR:DAT

Project editor Donna Gregory
Art editor Jacqueline Palmer
Assistant art director Penny Cobb
Picture Researcher Claudia Tate
Illustrators Chi Hang Li, Hayden Scott-Baron, Selina Dean,
 Emma Vieceli, Rik Nicol, Helen Smith, Wing Yun Mann
Proofreader Anne Johnson
Indexer Sue Edwards

Art director Moira Clinch
Publisher Paul Carslake

Manufactured by Provision Pte Ltd, Singapore
Printed by Star Standard Pte Ltd, Singapore

9 8 7 6 5 4 3 2 1

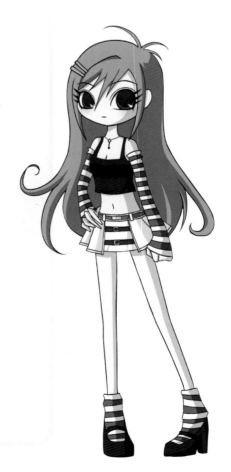

CONTENTS

お兄ちゃん!!!

Creating animation from scratch *From concept sketches and character designs to script writing to the latest digital tools, this book shows you the basics of what you need to create your own animation without the need for a huge studio.*

INTRODUCTION

▲ **Iconic images** *from some of the best-known anime will help inspire you.*

▲ **2D and 3D** *Integrating 2D and 3D will give your projects a professional look.*

Anime, or Japanimation as it is sometimes known, has been increasing in popularity outside its homeland in recent years. Not only are more Japanese animated feature films being shown in theaters worldwide, but TV shows are being broadcast over the expanding number of cable, satellite, and online channels that are looking for content to fill their timeslots.

Anime, through its origins in manga (Japanese-printed comics), covers a vast range of genres created with specific target audiences in mind, whether for small children, teenage girls, cyberpunks, or adults. As its popularity continues to increase, the demand for new shows increases, which means it is an ideal time to start creating your own anime-style cartoons.

This book is designed to take you through the basics of creating your own anime, from script to finished movie, using a combination of traditional animation skills and the latest in digital technology. It is very important that you learn and understand the basic animation principles before utilizing the vast array of digital tools available, because they are just that—tools—and not a magic wand that will do the creative work for you.

While the fundamentals of animation are the same throughout the world, there are certain key differences that identify anime, and these aspects are covered in detail here, so that even if you

are not conversant with Japanese culture you will be able to create an authentic-looking animation. But rather than just showing you how to imitate, this book will show you techniques that will allow you to create original anime-style animations that are becoming increasingly common and popular. This book also covers examples of some common anime character types to inspire you.

Because this book is aimed at novice animators, it covers a whole range of digital solutions, from free software up to professional-level programs, to demonstrate that it is as possible to create a good animation with a minimum of equipment as it is with a studio full of the latest technology. The most important thing is creative talent, and that can't be bought (unless you are a big Hollywood producer). Use this book as a guide to get you started, but remember that the only way to really learn is by doing. Once you have read this, you'll be ready to start working on your first short. If you get stuck, come back to it, but don't give up working on your anime: practice really does make perfect.

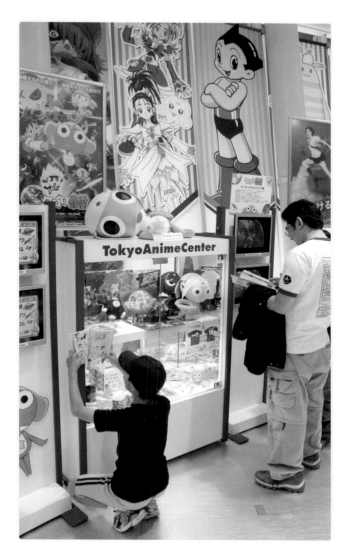

◄ **Increasing popularity** *The popularity of anime in Japan is evident at the Tokyo Anime Center, which celebrates all things anime. It is frequented by visitors of all ages.*

There is no doubt that in recent years there has been a huge rise in the popularity of Japanese animation (shortened to "anime") in the west. Television has always provided most people's introduction to anime, from the classic *Astroboy* (known as *Tetsuwan Atomu* in Japan) to more recent phenomena like *Pokemon*, *Beyblade*, and *Dragonball Z!*, with their huge marketing budgets and cross-media merchandizing tie-ins.

The shows broadcast in the US and Europe are just a tiny percentage of the output from Asia's prolific animation studios. The biggest hindrance to greater distribution has been language: dubbing into English and other languages is expensive and many broadcasters are not always willing to take a chance with investing in a niche market. Of course, the digital age has changed all that, not only for content providers but for creators, too.

- **Background of keyframes**
- **The place of anime in Japanese culture**
- **Anime or manga?**

▼**Universal appeal** Pokemon *and similar shows brought anime to a new audience in the west, crossing over into mass-market appeal with all manner of merchandizing.*

ALL ABOUT ANIME

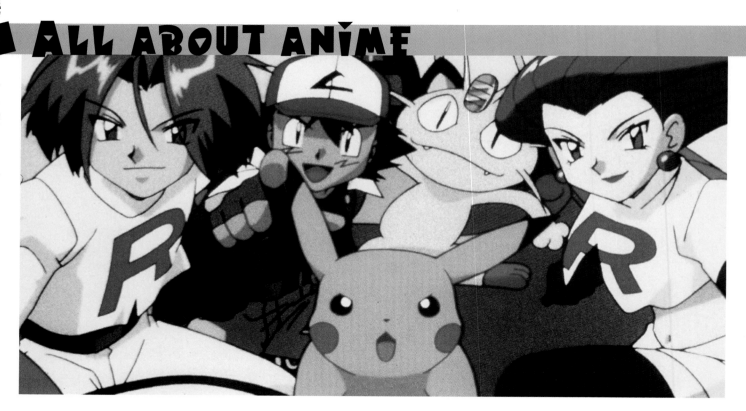

Digital age

The proliferation of cable and satellite television has meant a greater diversification and specialization of what is shown. After the introduction of animation channels like Cartoon Network, it became easier for smaller broadcasters to show programs that would otherwise never be aired outside their homeland. The communications and media expansion are not just limited to the airwaves—the internet now has all manner of information about anime available to anyone wanting to take the time to find it. Anime fans set up forums to discuss the latest releases and this, in turn, creates a market for DVDs and videos, which is probably the biggest category of anime. Many titles are released only through this medium, and are known as OAVs (Original Animated Videos). DVD technology has taken these a step further, and now DVDs often include multiple language dubbing and/or subtitles on one disc, which, combined with the compact size, means that production and international distribution costs are significantly reduced, therefore making it cheaper for fans to buy.

Wide-eyed wonders

For most people in the west, whose reference points are usually the shows mentioned previously, anime is about kids with big round eyes whose mouths move differently than the words they are saying. Although this is a sweeping generalization, it is a fair, if inaccurate, assumption. In the west, animation is usually seen as children's entertainment that adults only watch in the company of their offspring, with only a few exceptions (such as *The Simpsons*). In Japan, on the other hand, anime is watched by everyone. James Cameron's *Titanic* was the biggest-grossing film of 1997 in Japan, but it was matched by Hayao Miyazaki's *Princess Mononoke*, a film that was only shown in limited art-house release overseas. It was a similar story with Miyazaki's Oscar-winning *Spirited Away*, in spite of Disney's backing.

◀ **Characteristic anime** *Large round eyes, pointed chin, limited features detail, and cel shading are all typical of anime characters.*

Manga and anime for all ages

The fact that almost everyone in Japan reads manga (comics) explains the popularity of anime, as many animated films are based on manga, just as novels are adapted into films in the west. This generation-spanning love of animation is attributed to a long tradition of visual storytelling, which was made popular with the work of the artist Hokusai, who coined the term "manga." His drawings weren't really stories, but rather collections of character sketches of everyday life.

Many of the mangas sold in Japan nowadays are about everyday life. There are salaryman mangas, housewife mangas, and another very popular genre, sports mangas. All these different categories also get turned into anime.

▲ **Long-running stories** *Many characters in long-running mangas grow up as their audiences do: they get married, raise children, and so on. The Korugo series is one of the most popular with older readers in Japan: the series has been going for dozens of years, and many readers who bought it as teenagers still buy it now.*

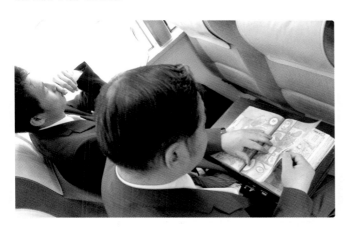

◀ **Popular culture** *A mature businessman (or "salaryman") reads manga on the train. This is much more acceptable in Japan than it would be in the west.*

Cultural boundaries

Because the content of so many anime is inextricably bound with Japanese culture, their meaning is often lost in translation when taken to the west. One of the first casualties is the use of puns in titles; the subtlety of the wordplay often does not cross linguistic borders. This also goes for many other social intricacies which local viewers understand innately but westerners may find either baffling or simply quaint. Ideals such as obligation, honor, family, and society before self are at odds with the way most westerners behave. For fans of anime, it is worth brushing up on Japanese culture to understand all these different nuances, and for anyone seriously considering creating anime that looks genuine, it is a must.

In foreign markets, stories that go beyond cultural and geographic boundaries are the most successful, especially with older audiences. Sci-fi and cyberpunk titles like *Akira* and *Ghost in the Shell*, in particular, not only made anime accessible but also were huge influences on some of today's major filmmakers. *Akira* director Katsuhiro Otomo's 2005 film, *Steamboy*, is set in Victorian England, and yet it is still recognizably anime through its drawing style, cel-shading, and finely detailed artwork. But these films are exceptions that take years to develop and create.

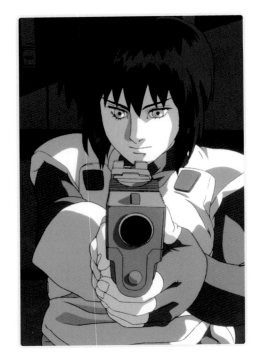

◀ ▼ **Inspiring movie** *The groundbreaking movie,* Ghost in the Shell *(left), went on to inspire a major, long-running TV series,* Stand Alone Complex *(below).*

▲ ▶ **Complex storylines** *Taken from popular manga sources,* Akira *(above) and* Ghost in the Shell *(right) brought complex cyberpunk stories to a youth market looking for both intelligent content and high-quality animation. These two movies are responsible for much of the increased interest in anime in the west.*

Check these out

If you're not familiar with Japanese culture, it is definitely worth some research. There are many good books and websites, including these:

Introduction to Japanese Culture, Daniel Sosnoski (ed.), Tuttle Publishing, 1996

The Japanese Mind: Understanding Contemporary Japanese Culture, Roger Davies and Osamu Ikeno (eds), Tuttle Publishing, 2002

www.japan-zone.com
For all things Japanese

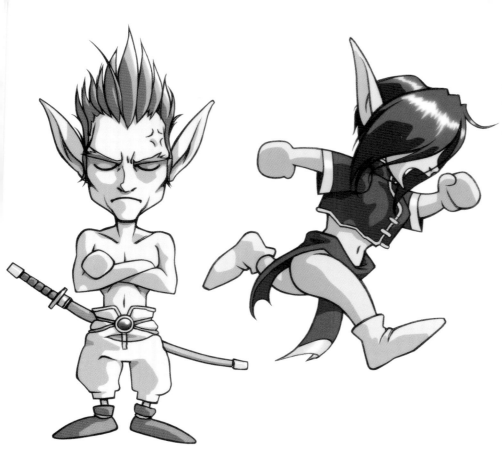

▼ **Chibi** *A common style of anime is known as chibi (meaning short or sometimes written as CB for child's body) or super deformed (SD). These are characterized by short bodies and appendages with large heads.*

Blurring the lines

As the world gets smaller through more advanced communications systems, cultural boundaries merge. In the case of anime it seems to have gone full circle. Originally the Japanese took western animation and put their own slant on it. Now, anime style has been absorbed back into western animation to create a new hybrid, using the look of anime with occidental stories and characters. Some of the better examples of this can be seen in shows like *Teen Titans Go!* (DC Comics, based in the US), which even utilizes super deformed (SD or chibi) characters and a theme song by Japanese pop group Puffy AmiYumi. Jamie Hewlett used his anime influences when he created the look of the music group Gorillaz, who have proved popular worldwide except, interestingly, in Japan.

As a new generation of artists raised on a mixed diet of anime and western animation start to create their own styles, we are likely to see new animation with braver story lines that will appeal to a wider audience.

► **Western and eastern**
The Pink Panther (above right) is a good example of traditional western animation, and the artworks for Gorillaz (right), although a western band, are clearly influenced by anime style.

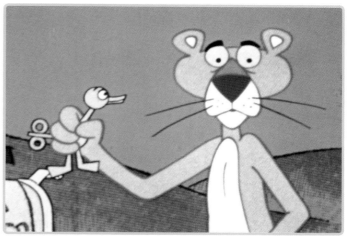

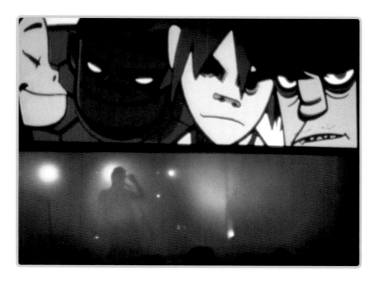

ANIME STYLE

From the 1960s onward, anime has developed its own instantly recognizable style. From its unique storytelling to its artwork, anime has been quietly asserting its influence over the international world of animation. Like Japanese society, anime is now a combination of traditional skills and advanced technology, tempered by artistic pride and attention to detail. The techniques outlined in the coming pages can be applied to traditional cel animation or to the latest in 2D and 3D digital animation. By learning these fundamentals that make anime what it is, you can start creating your own anime-style animations.

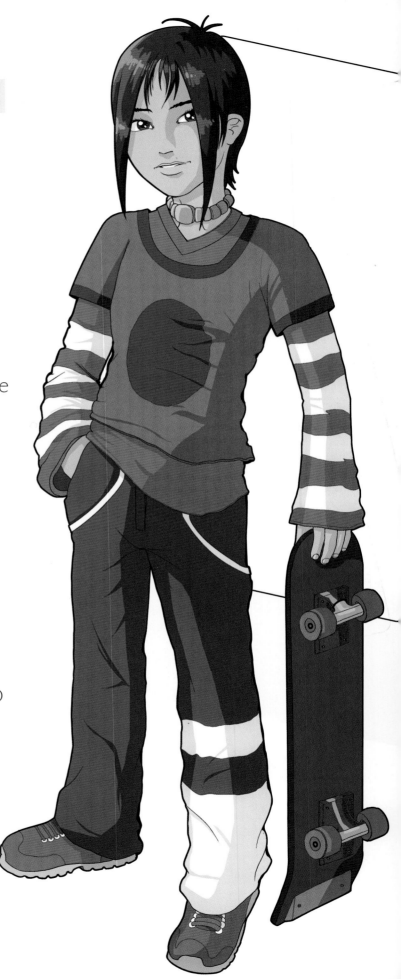

What distinguishes anime from western animation and cartoons and makes it popular outside its country of origin? Without going into a detailed cultural study of the history of anime, its appeal can be broken down into several components that can be defined as "anime style." By understanding what these are, you can create your own anime-style animations.

The first thing to consider is that anime is simply Japanese animation (sometimes known as Japanimation, but more commonly now referred to as anime), and has as many varied styles as western animation—although western animation does incorporate a much wider range of cultural backgrounds and influences. What does make anime distinctive is the bold use of colors, angular characters, and dynamic visuals to tell tales of fantastic imagination.

14 ANIME ESSENTIALS

- **The origins of anime style**
- **The advantages of digital**

▶ **Typical styling**
Distinctive cel-shaded characters capture the essential anime style.

Stories

Japan's cultural heritage is a rich source of stories and characters that can be adapted to different scenarios, and because of this heritage most people are familiar with the tales and enjoy seeing them retold, even as sci-fi. Science fiction features very strongly in anime, with a lot of it post-apocalyptic.

Use of fantasy

The use of traditional legends as source material lends itself to the use of fantasy, because so many of the stories are filled with magical creatures and mysterious characters. It is also connected to the fact that animation in Japan is not considered just the preserve of children. The restrictions placed on western animation by studios and marketing departments to make films child-friendly don't really exist in Japan, which leads to more adventurous storytelling and greater flights of fancy.

▼ **Themes** *Futuristic, post-apocalyptic, and technological themes all reflect aspects of contemporary Japanese society taken to extremes.*

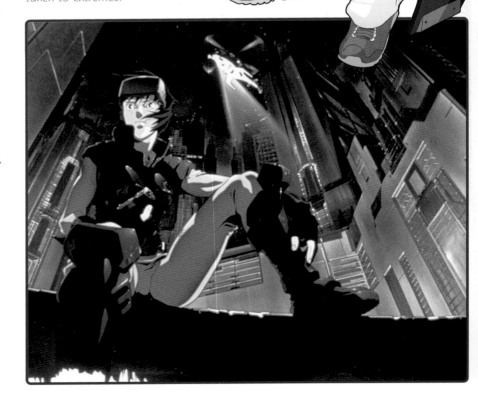

Visual simplification

A lot of the charm of anime comes from its selective use of minimalism. This encompasses not only the drawing style but also the use of color and techniques to simplify the animation process, such as moving the "camera" instead of animating the scene. Paring down the animation also speeds up the production cycle, which can be important when creating a weekly show. However, not all anime is simplified, as can be witnessed in the works of Studio Ghibli (below).

◀ **Vector characters**
Characters can be created entirely with vectors and mathematical curves, producing a very simple and design-centric style. Because they are made entirely from shapes, they are often very simple to move around, with a look unique to digital anime. Vector characters are also popular with web-based animations (see page 99: online animations).

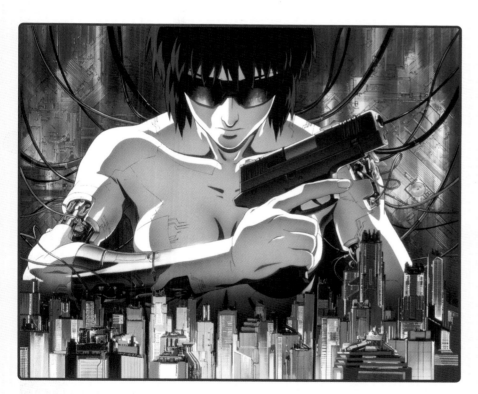

▲ **Nudity and anime**
For the Japanese, nudity is part of life and birth, even if the character is cybernetically created or enhanced, as in the anime classic Ghost in the Shell.

Character types

In spite of the apparent originality of anime and all its fantastic settings, most anime are fairly formulaic, whether this stems from the design of the characters or their personalities and roles. Archetypes exist in both eastern and western animations, but in anime they are more obvious character types, such as the lone wolf or the fool (comic relief).

Nudity and sexuality

One of the things anime is famous for is its exotic and exaggerated use of sexuality, which is not limited to adult films, or *hentai*. Even shows aimed at younger children have been known to have nudity, although here it has nothing to do with sexuality, and is usually for comedic reasons. Nudity is not considered a problem in a country where communal baths are a norm and the common religion does not bear the taboos of Christian churches. The viewers are also smart enough to realize that they are just watching drawings.

Several different anime techniques have been developed in Japan, enriching the visuals with style and energy. Many of these techniques are simple; they make it easier for the animator to convey the action and behavior of the characters.

Key characteristics of anime

Exaggerated perspective (trees and buildings)
Images are presented with an almost fish-eye lens effect to enhance the speed and depth of the event.

Smoke trails
Trails of smoke around the character help to show movement.

Speed lines
Speed lines are a technique adopted from manga, to represent objects moving so fast that only a trail is left. By showing individual lines in different frames it helps to express motion..

Stretching the view
Stretching the view of the character gives a sense of energy.

Blurring
Stretching and blurring the subject in this frame helps to accentuate the speed and motion of a movement.

Background blurring
The subject of this frame remains relatively focused, but the background is blurred to indicate the camera's movements as it follows the subject.

Animating expression
The character has an extreme expression to show frustration. Mouth turned down, eyebrows furrowed, and crossed arms all add up to convey the character's mood.

Pacing

Pacing is the way the action and story unfold. Western animation and filmmaking have come to rely on constant movement—whether from the actors, the camera, or in the editing—to maintain a fast pace. On the other hand, anime is not afraid to have long shots of stillness, which require minimal animation and establish a dramatic mood. An excellent example of this is in *Blood: The Last Vampire*, where the hero, Saya, is sitting on the Ginza subway and there is no movement, just the sound of the train. The stillness makes the shot seem much longer than it is, and requires only one drawing.

The best way to understand the different anime styles is to watch lots of different films and television shows. Copying is a good way to start, but ultimately you will want to develop your own style. Find the elements that are common to most anime and the ones that appeal to you and start creating your own hybrid. By pausing animation or re-watching scenes, you can analyze the techniques and apply them to your own projects.

www.wooti.net
Creators of *Telephone Ice-cream* and other anime projects.
www.journeyoflight.co.uk
A short story about a girl and a cat.
www.sweatdrop.com/animation
Various original animations in anime style.

Manga vs. anime

It is common for anyone new to Japanese pop culture to confuse manga and anime, which is compounded by the fact that one of the biggest anime distributors in the west is called Manga Entertainment. The obvious difference between the two is that anime refers strictly to animation, whereas manga means printed comics and graphic novels. The confusion continues because many anime start life as manga.

Another big difference between manga and anime is the level of detail given to the characters and drawing. On the printed page, a single image is put under more scrutiny and has to impart more information, whereas animation needs up to 24 drawings to make just a second of action, so economy of line is very important. Manga relies on drawn detail to pull you into the story, while anime has the advantage of movement and sound. Of course, these differences aren't exclusive to Japanese comics and animation.

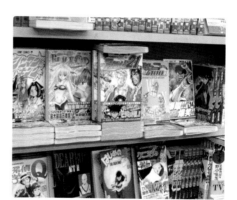

◀ ▲ Wide appeal *Manga appeals to every taste and walk of life, from children's stories to very adult material.*

▶ ▼ Compare and contrast *The look of the characters changed dramatically between the manga (right) and the anime (below).*

Use of color and palette

Anime is invariably in color, whereas manga is usually in black and white, because this is cheaper and easier to print, though the comics' covers are usually in full color. The use of lighting and color in anime makes a huge difference in the overall atmosphere of a production, and the look varies from director to director and studio to studio. Compare the manga of classics like *Akira* or *Ghost in the Shell* with their anime versions to see how different styles are used. One of the standout features of anime is the use of cel shading, which not only sets it apart from manga but also from other styles of animation.

More about this can be found on page 18.

The use of color shading on the characters is one of the most distinctive characteristics of anime that has distinguished it from western animation. Japanese animation adopted a method of solid-color shading very early on in its development—as early as the 1950s and 60s. In contrast, the characters in western animation were painted with flat colors. For anyone brought up on a diet of television cartoons, this lack of shading is never apparent until it is pointed out. Although a few feature-length animations used shading on characters as far back as 1939, such as some of the scenes with the dwarfs in Disney's first feature, *Snow White and the Seven Dwarfs*, the technique was used sparingly in the west until the 1990s. The arrival of the digital age has made the extra work viable.

18 CEL SHADING

- **Creating light and shadow**
- **Adding form and volume**

Why use cel shading?

Using cel shading in animation creates a stronger illusion of volume than flat colors. It emphasizes the characters' movement and their presence within an environment. In live-action film, a scene's mood is usually portrayed through the use and placement of lights. Light is also used to convey the time of day. In 3D CGI animation, the use of lighting is vital to make it look real, and this is reiterated with the application of a cel or toon render. In 2D animation, it is the use of shadows and highlights that gives the best impression of light. These are easier to represent with a solid-color block than with a graduated, continuous tone.

Different surfaces and materials can be easily signified with cel style because of the high contrasts between shadows, mid-tones, and highlights. Some common examples are: metal, plastic, rubber, hair, and flesh.

▼ **Working with a single shade** *A single shade for shadows can be enough to add form to the character. Consider the placement and color of the light source.*

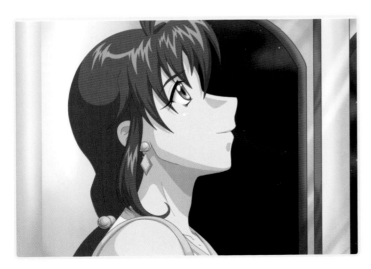

◄ **Updating cel-shaded layers** *Cel shading is usually, but not exclusively, applied to the elements that are animated because it is easier to update consistently than the continuous tone used for static areas like backgrounds.*

◀ **Complex cel shading** *The more colors you add to the shading, the more complex and time-consuming it is to produce each frame. Adding "airbrush" effects will further complicate matters, even if they give a softer look.*

▶ **Software–generated** *Vector software is ideally suited to creating cel-shaded images as it works with blocks of solid color, which can easily be edited between frames to retain consistency.*

shadow

base color

highlight

▲ **Minimizing shading** *A typical approach to anime cel shading, using one base color, one shadow, and one highlight (see enlarged area). Notice how the brightness and contrast of the colors give the impression of a midday summer sun.*

The array of subject matters and art styles seen in anime is vast—as vast as those of traditional cinema. In fact, the range of ideas is so varied within anime that pigeonholing it as a genre ignores its diversity. From giant robots and monsters to romantic love affairs, from epic war dramas to ghost stories, and everything in between, there isn't a subject that hasn't been covered in anime's history. There are many other niche genres of anime such as hentai (erotica) and sports (car racing, baseball, golf, boxing), as well a host of sub-genres of those outlined here.

▤ **Comparing anime categories**

▤ **Art style characteristics**

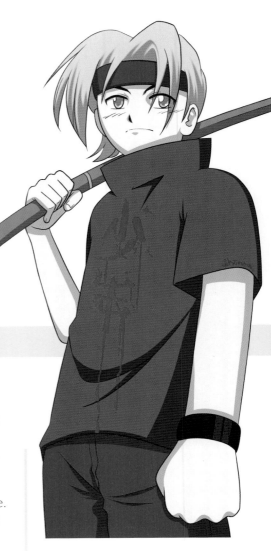

20 ANIME VARIATIONS

The majority of anime extends beyond its core premise to cover a wider assortment of subject matters, as well as a variety of thematic elements. This can make the process of categorizing very difficult. A show may have a simple plot, but will be simultaneously interwoven with far more complex storylines and characters. It is not uncommon for an action-themed anime, for example, to also involve humor, romance, and even political or social commentary. Conversely, a romantic anime may involve action scenes. There isn't really any set rule for this kind of genre cross-pollination, which is evident in most anime. It's what keeps old ideas fresh for each new generation. Here are some of the more specific, well-known anime genres.

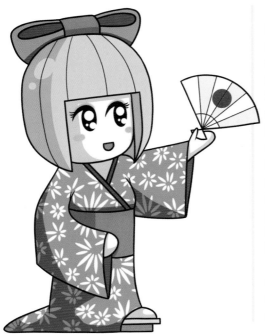

◀ **Kodomo**

Kodomo means "child," though the term "kodomo" is now more synonymous with a specific genre of anime rather than its literal meaning. Kodomo is targeted at the preteen audience, and focuses on more innocent and childish themes. It has a very distinct style, usually opting for simpler line-art and bright vivid primary colors. Characters like Doraemon and Anpanman are perfect examples of the kodomo and have become iconic figures in Japan, instantly recognizable and loved for their cuteness. Successful kodomo characters often become cross-market brand identities, such as *Hello Kitty* and *Astroboy*.

▲ **Shonen**

Shonen (Japanese for "young boys") refers to any titles mainly based on action and special effects and aimed at young males. *Dragonball Z* is a good example of the genre, using martial arts to appeal to the audience. The term "shonen" can also have a broader definition. Teen comedies based on adolescent relationships like *Love Hina* are considered shonen because the story is told from the male protagonist's point of view. Shonen anime is probably the most pervasive of the anime genres, because young males have the greatest interest in anime.

▲ Shojo

Shojo (Japanese for 'young girls") titles are more often about the more emotional elements of life, such as romance and friendship. Shojo titles, like *His and Her Circumstances* and *Fushigi Yuugi*, explore the intricacies and awkwardness of teen relationships, and are a huge success with both the sexes. The subgenre known as maho shojo (magical girls) is similar to traditional shojo anime, but is more fantasy-based, and aimed at a younger, pre-teen audience. *Sailor Moon* is the best-known series of this sub-genre, and its kitsch appeal has garnered anime fans of all ages.

▼ Seinen

Seinen (or "progressive anime") is anime aimed at a young adult audience (18–30 years old) and differs from the average shonen anime by having a stronger focus on plot and character development, and less focus on excessive action. More intelligent themes such as psychology, satire, and philosophy feature in the stories, and existential debates are often included. Cyber-punk hits like the highly regarded classics *Akira* and *Ghost in the Shell* are examples of this genre. Not as popular as lighter anime such as Studio Ghibli features, they are more akin to art-house movies.

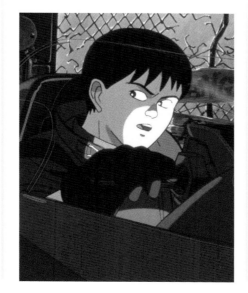

▲ Mecha

Mecha is any anime featuring giant robots. Anime-style robots are usually portrayed anthropomorphized with a bipedal human form and great agility. The genre is said to have begun with Mitsuteru Yokoyama's 1956 manga, *Tetsujin 28-go* (also known as *Gigantor*). Shortly after that, the genre was largely defined by *Mazinger Z*, which pioneered the very popular die-cast metal toys that paved the way for the ultra-successful *Gundam* toys. In the 1980s, shows like *Gunbusters* and *Macross* (or *Robotech*) were considered the pinnacle of anime and brought it to the attention of a larger, worldwide audience. The genre is still very popular internationally, with shows like *Evangelion*, *RaXephon*, and *Gundam*.

Astroboy
Created by Tezuka in the 1960s as a manga character, Astroboy proved just as popular as a TV anime series. Note the simplicity of the character. Cel shading is used, but sparingly.

Right back at the beginning of the 20th century, Japanese filmmakers began experimenting with the animation techniques being developed in America. Until the 1950s, anime output was limited to a relatively small number of generally short films. Not all were drawn: a small number of puppet and cut-paper stop-motion animations were also made. These films were known as "*doga*" (moving drawings). It wasn't until the 1960s that the animations we recognize as anime started to appear with the arrival of Astroboy, possibly the most famous animated character to come out of Japan. It was at this time that the term anime (–shon), taken from the western word "animation," was coined.

CLASSIC VS. MODERN

- **Development of the genre**
- **What to watch**

Wanting to compete on an international level, many Japanese animes of the early 1960s were based on well-known European stories, even though it was the feature-film adaptations of sci-fi manga stories such as *Cyborg 009* that proved to be popular. However, it was Osamu Tezuka's black-and-white TV series, *Astroboy,* that brought Japanese animation to the notice of the west. At the same time another sci-fi series, *Tetsujin 28-go,* was being made and later appeared on western television as *Gigantor* (this has recently been remade as a color series and a live-action feature film). Both of these series featured young boys with the huge eyes that have since become anime's trademark. *Kimba the White Lion,* Japan's first color animation, also appeared at the same time.

 As the decades passed, most anime was restricted to television, although its content was becoming oriented toward teenagers and young adults, with the bulk of it having a sci-fi theme featuring space travel and robots. By the 1980s, high-quality productions such as *Dragonball* and *Gundam,* which presented complex characterizations with dynamic action sequences, were becoming popular internationally. Home video-players were now commonplace and opened up a whole new market of OAV (original animation video), which meant shows that previously couldn't get airtime found a new audience.

Essential classic and modern anime viewing

Best classic anime (TV and OAV)
Tetsujin 28-go (Gigantor)
Mighty Atom (Astroboy)
Mach Go Go Go (Speed Racer)
Mobile Suit Gundam
Space Battleship Yamato
Robotech
Nausicaa of the Valley of the Wind

Modern (TV series)
Dragon Ball
Neon Genesis Evangelion
Cowboy Bebop
Sailor Moon
Ghost in the Shell: Standalone Complex
Escaflowne

Feature films (OAVs)
Akira
Barefoot Gen
Ghost in the Shell
Metropolis
Princess Mononoke
Metropolis
Voices from a Distant Star
Steamboy
Animatrix

Feature-length animes

The 1980s saw the release of a number of classic feature films, including *Barefoot Gen* (1983), *Grave of the Fireflies*, and *Akira* (both 1988). *Akira* became the new benchmark by which other anime were measured. The 1980s also saw the rise of Studio Ghibli under the direction of Hayao Miyazaki, generally recognized as Japan's greatest animator, and definitely its most successful. His films might not have had the international impact of *Akira*, but they are all still as stunning today as the day they were released, and are enjoying a revival on DVD in the west, following the success of *Spirited Away* and *Howl's Moving Castle*.

The arrival of digital anime

The 1990s saw the establishment of digital animation. This is where we start to see the differentiation between classic and modern anime. Although there had been experiments with digital animation before then, especially in the west with films like *Tron*, anime was still all about the art of cel animation, which is what makes the Studio Ghibli films timeless. *Ghost in the Shell* (1995) was the breakthrough movie for digital anime, and soon other animators began to use digital techniques.

Although the basic themes have not changed over the decades, with sci-fi/fantasy stories being the most prevalent, the introduction of digital animation and affordable systems means that anyone with the talent and patience can produce an anime and, thanks to the internet, get an audience. This means that there is a greater diversity of stories within the standard genres, with sub-genres and crossovers attracting new audiences. While most western animations opt for CGI, at least for feature films, anime still relies on hand-drawn 2D animation, which is then enhanced by digital techniques. This epitomizes Japan's ability to unify traditional craftsmanship with advanced technology to produce something unique.

▲ **Modern anime** *such as Akira, is visually more sophisticated than classic anime, thanks to the advent of digital tools, which speed up the animators' work.*

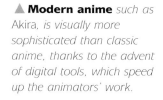

▶ **Astroboy grows up**
A still of Astroboy from the 1980s. Compare this to the 1960s' image of the same character shown above. Drawn by the same animator (the great Osamu Tezuka), you can see the character's development—the cel shading is more prominent, and the lines are even simpler in the later image.

While it is easy to simply consider it a mere afterthought, background art actually plays a significant role in the overall aesthetics of a piece of animation. Take a closer look at any decent anime, and you'll quickly realize that the type of backdrops anime employs are beautifully vibrant and rich with detail. This is mainly due to the fact that most anime studios have a dedicated team of background artists who are devoted to the task. This makes sense in a commercial setting because the disciplines of drawing characters and drawing backgrounds are so wildly different that someone who can competently draw both characters and background is very rare indeed. Obviously there are exceptions, but it is far from the norm. Even in the world of manga where projects are mostly a solo affair, artists often outsource the background art to someone else, leaving them to concentrate on the characters.

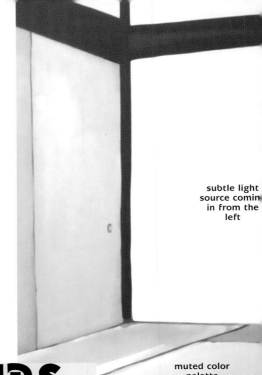

subtle light source comin in from the left

muted color palette

24 STYLIZED BACKGROUNDS

- **Using backgrounds to set the scene**
- **Choosing appropriate backgrounds**

The significance of background art should not be underplayed. Just take a look at *Akira*'s neon night-time cityscapes, or the lush forestry of *Laputa: Castle in the Sky*, and you'll understand how background art can work to stunning effect. And all anime needs some kind of background, even if it is very basic, so it is definitely worth learning how to create your own (see pages 86–87 for more detail).

▶ **At night** *The bustling city at night, lit by neon. This type of imagery is synonymous with Japan, and striking in appearance. The soft lighting used in this example achieves an atmospheric hazy effect that makes it look as though it is raining lightly.*

▶ ▶ **Cityscape** *A typical Japanese cityscape on a bright sunny day. The vibrant colors accentuate the abundance of sunlight, and the light reflections on the building's glass windows further enforce this intense brightness.*

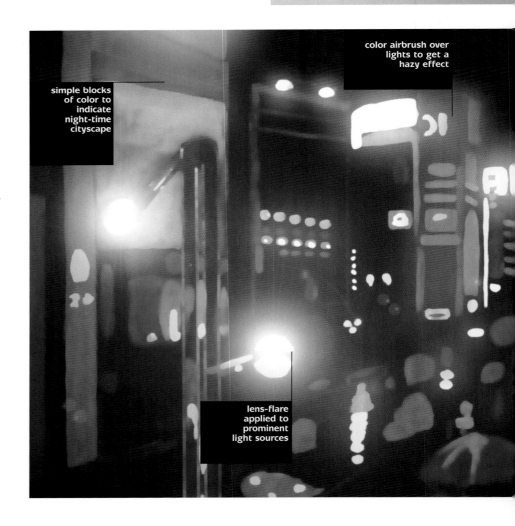

simple blocks of color to indicate night-time cityscape

color airbrush over lights to get a hazy effect

lens-flare applied to prominent light sources

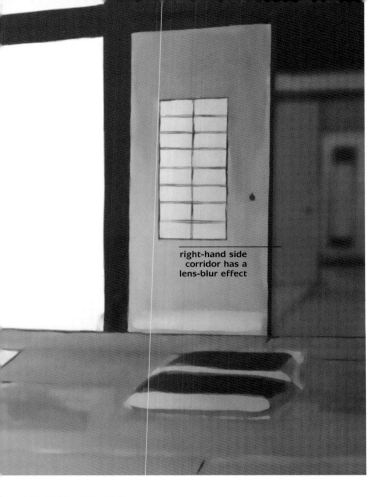

right-hand side corridor has a lens-blur effect

- Anime backgrounds always have a very organic, painted look (regardless of whether they're done manually or digitally), yet they remain doggedly representative.
- Backgrounds are often extremely colorful. This gives them a vibrancy to match the colorful nature of the character art.
- Unless the background is actually animated, they never incorporate the use of outlines. By doing this not only do the backgrounds look more natural, but the distinction between background and foreground is emphasized.
- Geometrically, they are usually very sharp and coherent. Lines and edges are kept very clean and straight, resulting in a tidy look.
- Backgrounds often involve a lot of lighting effects, such as lens flares, spotlighting, and overexposures.

◀ **Interior** *A shot of a typical Japanese home. The neutrality of the colors gives a very calming, Zen-like tranquility to the scene. Traditional Japanese homes such as these are more commonly found in rural Japan, and are not so appropriate for urban cities like Tokyo.*

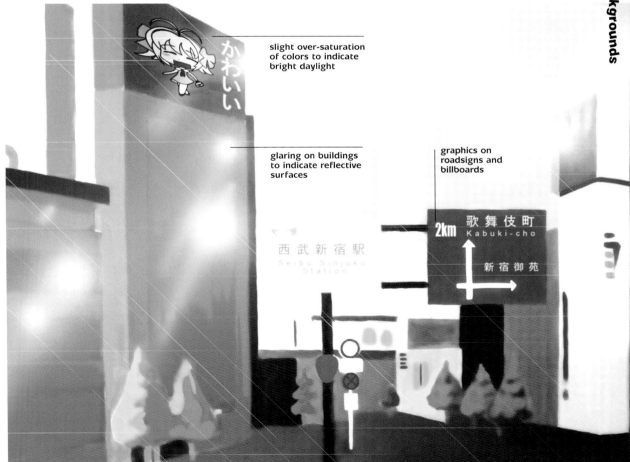

slight over-saturation of colors to indicate bright daylight

glaring on buildings to indicate reflective surfaces

graphics on roadsigns and billboards

かわいい

2km 歌舞伎町
Kabuki-cho

新宿御苑

西武新宿駅
Seibu Sinjuku
Station

STORY AND CHARACTER DESIGN

Drawing and animation skills are vital for producing your own anime, but you need to have a great story and characters. There are some basic rules to storytelling and scriptwriting that will make your film more engaging and watchable, whether it is ninety seconds or ninety minutes long. This chapter will take you through all the pre-production stages of animation—coming up with a story, turning it into a script, making storyboards, and designing characters that fit into the anime archetypes and conventions, with some specific examples to inspire you.

Pre-production

1 Start with the all-important great idea, which has to be turned into a workable script or screenplay.

2 Create accurate storyboards and test them with an animatic.

3 Record the voiceover. Can also be done in post-production, depending on your preference.

4 Break down each scene for timing to calculate the number of frames that require drawing. The x-sheet is used for this.

28 PLANNING YOUR ANIMATION

■ **Creating an anime**, or any type of animation, requires forward planning to ensure the whole process goes smoothly. Before you proceed with your anime production, be certain about the details of your project. Will your idea be viable? Can you translate it into workable script? Do you have the skills to transform it into a finished animation?

■ **Understand the animation process**

The production cycle of any movie, animated or live-action, is divided into three major steps: pre-production, production, and post-production. At the risk of stating the obvious: pre-production is everything you do before you begin the actual animation process (production) and post-production is everything that comes after.

Pre-production

Pre-production is the planning stage, where you assess the project's viability and create a schedule and budget. It is also when the bulk of the creative work is done, and you start to turn your idea into reality. This begins with the script or screenplay (see page 38), so you have a tangible form to work with. Once you are satisfied with your script, you need to convert it into visual information.

Production

5 If you are going entirely digital, draw keyframes with a stylus and graphics pad, utilizing the software's exposure sheet to work out timings. Skip to step 6.

5a For a more traditional start, draw each frame with pencil on punched animation paper.

5b Scan the drawings, using an animation peg bar attached to a scanner. Always name everything with a logical numerical sequence to match the x-sheet.

6 Trace and clean up the pencil scans using the animation software's drawing tools. This replaces the traditional inking stage.

Animation is a visual medium, so it is helpful to sketch out key scenes, characters, and moments while thinking of the other details, or even while you are doing something quite unrelated, if an idea comes. The important thing is to get the ideas on paper, so you can decide what you need to tell your story. Make character sheets with concise notes and details to ensure the characters are consistent and easy to reference. When you have refined your character designs you can start building the storyboards from your script. One part of the process that comes down to your choice of working methods is the voiceover. This can come at the end of pre-production, so that it can be incorporated into the storyboard/animatic (see page 36) or during post-production. Generally, western animators record the voices first to ensure accurate lip-synch, while Japanese record once the animation is finished so the actors can respond to the action and emotions onscreen.

Production

This is where your idea comes to life. Build up the x-sheets, using your storyboards. These will tell you exactly which drawings to create for every second of the animation. Then draw the keyframes for each "shot" (see page 56). Although most animators work digitally, you may prefer to work with paper and pencil for the initial stages. Each action is then completed with the in-between drawings, or tweening.

Once a shot is complete, the drawings should be run in sequence to check for accuracy. This is called a pencil-test. Once approved, the pencils are inked: meaning that they are scanned and cleaned up, with consistent lines drawn over the pencil templates, ready for "painting." Like inking, painting has become a completely digital operation. This production stage is a long, arduous task even with the assistance of the latest digital tools.

Post production

When you have finished all the drawing, inking, and coloring you will have a collection of sequences that will need to be edited together. Animation does not offer the same range of choices that live action films do, especially if you have done your pre-production properly. Editing requires you to seamlessly join all the scenes together and add the voiceover (and record it if you haven't already), music, special effects, as well as titles and credits. Post-production is also where you arrange your distribution, whether it is DVD, theater, broadcast, or simply putting it on the internet.

Somewhere in this process you should consider how to market your anime and actually get it seen. This can be done either at the beginning, to raise funds, or at the end, when you have a product to show. Marketing is as important as animation if you want to be successful, and will often use up the largest part of your budget.

Focus on what you have available

Other than scheduling your work flow, as outlined above, be sure to design your project around the talents, abilities, facilities, and time available. Ensure the talents are capable of producing the result that will match your vision. Alternatively, adjust your animation to match the talents at your disposal. Avoid over-complicating your first anime project. By aiming to produce a piece beyond your scope, you could end up with something that fails to satisfy both you and your audiences. Allow yourself a certain amount of flexibility. Can any scenes be removed or trimmed without hurting the final results too much? Split your tasks into "needs" and "wants," deciding which aspects of the animation are absolutely necessary, and which are simply icing on the cake. Always look for the simple solution that will make your project look better. The following pages discuss these stages in more detail.

Post-production

7 Color the frames using digital paint tools.

8 Export the completed scenes to a format compatible with your editing system.

9 Edit scenes and add voice-overs, sound effects, and music. Titles and credits are added here.

10 Save the finished animation to an output media relevant to your intended method of viewing and distribution.

The importance of a good story

cannot be overstated. An audience will endure even the ropiest of productions if the story being told is gripping enough; such is the power of engaging narrative. This is especially true in anime. Many low-budget shows have made it big in the mainstream by offering fans excellent stories and memorable characters instead of flashy animation.

However, the precise ingredients needed to compile a great story are elusive. The movie industry, after all this time, still frequently gets it wrong, as the multitude of below-average Hollywood films irrefutably proves. So what makes a good story? Or, more relevantly perhaps: what makes a good anime story?

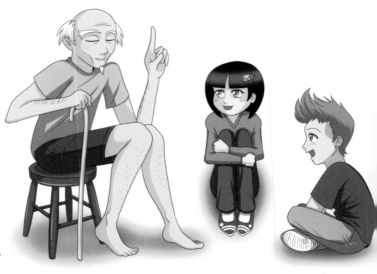

▲ **Tell me a story** *Stories have been passed down orally through the generations for thousands of years.*

STORYTELLING

- **Creating a gripping narrative**
- **Choosing a subject for your story**

Oral tradition

Storytelling has always been, and always will be, a fundamental part of being human. Before the advent of newspaper, radio, and television, stories were communicated orally—from parent to children, from neighbor to neighbor, in an effort to convey a message or feeling. The popular ones gained popularity through being retold, adapted, and improved from one teller to the next, seamlessly traveling down the generations. These stories sustain ideas and ideals, teaching us valuable life lessons.

Before the proliferation of widespread literacy (and printing technology), storytelling was restricted to being presented orally. This form of storytelling sees the teller creating the experience, while the audience perceives the message and creates personal interpretations of the scene in the form of mental images. In this sense, the audience becomes a co-creator of the story, and is engaged with the storyteller in a kind of dialogue. Good storytellers would exploit this and improvise their style (or even the story) according to the whims of the audience.

Sometime around the ninth century AD, woodblock printing was introduced in China. This technology gave people the ability to mass-produce text and images for distribution, and revolutionized the spread of knowledge. As printing technology evolved, the art of telling stories through written words became more popular. This gave way to the propagation of short stories, poems, and novels that covered a diverse range of topics and issues, and helped advance the sophistication of storytelling.

▶ **Picture books**
Pictures have been used in many forms through the centuries by people from all cultures to preserve their stories.

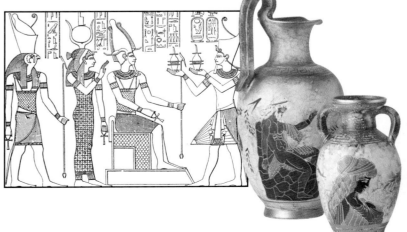

Comic book beginnings

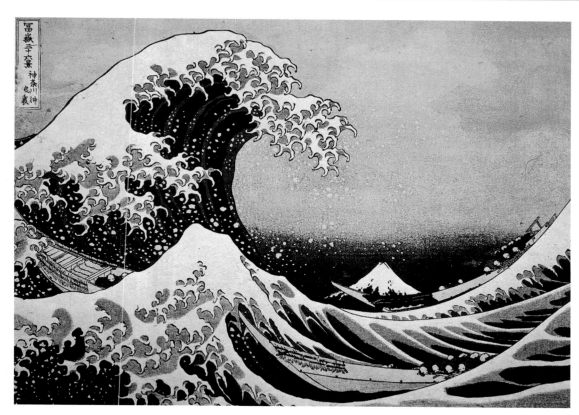

Woodblock print
This print by Hokusai is from 1881. The stylized representation of the elements was a huge influence on the evolution of anime.

The printed comic

While the origin (and even the definition) of comics is a gray area that is forever debated, there is no arguing that the format was crystallized with the invention of print. According to many experts, the pioneer of modern comics (as we know them today) was Rudolph Töpffer from Switzerland, who published *The Adventures of Obadiah Oldbuck* in 1837. However, the 1895 *Yellow Kid*, created by Richard Outcault, is often cited as the first comic strip, because he was the first comic artist to use speech bubbles.

The birth of manga

The term "manga" was coined by the famous woodblock artist Hokusai (1760–1849), who is responsible for one of Japan's most famous pieces of art, *The Great Wave*. Woodblock prints became very popular during the 17th century, and *ukiyo-e* (colorful woodblock prints, literally: "pictures of the floating world") enjoyed great success. These prints were the manga of their day: they were cheap to mass produce, affordable to own, and visually stimulating. *Ukiyo-e* prints covered a range of topics from salacious fantasies to satirical humor, as well as current aspects of popular culture like theater and fashion.

When Japan opened up for trading with the west,

many western ideas and culture seeped into Japanese society. Western artists began teaching such then-foreign concepts as form, composition, anatomy, and perspective to the Japanese. This cross–pollination of ideas began something of an artistic revolution. But it wasn't until 1945 that manga, by its modern definition, was born. Osamu Tezuka is widely acknowledged as the founder of story-based manga. He went on to produce the likes of *Astroboy* and *Black Jack*, after being massively influenced by some Japanese war propaganda animation that copied the Disney style of illustration.

Before Tezuka, most Japanese comics were single- or four-panel sequences that primarily dealt with political satire or humor. Tezuka established a filmic quality to storytelling in the comic format, and introduced the use of mini-episodes that collectively contributed to an overall story arc. He also implemented Disney-like facial features to his characters. By exaggerating the eyes, mouth, and nose he achieved a kind of esthetic style that was previously unseen in Japan. This heavy stylization has remained in manga since, and has influenced every manga artist to some degree. Some say this ethos is reminiscent of the old *ukiyo-e* tradition, where images project an idea rather than actual reality.

The traditional story arc

A story arc shows the evolution of a character or situation from one state to another in order to effect change and keep the story from stagnating. This is where the "rags-to-riches" formula comes in; a weakling rises through adversity to become a hero; or the reverse, a character loses a loved one and descends into madness. This was famously observed by Aristotle, the Greek philosopher, who insisted that in order for a protagonist to become a hero, he must first fall from grace before rising from the ashes. This makes great heroes possible, and is manifest in almost every conventional story ever told.

▼ **Traditional themes** *Knowing nods to traditional Japanese culture are abundant in anime. Traditional costumes are habitually portrayed, and themes of samurai and geisha are becoming more popular as the west shows ever more enthusiasm for such topics.*

Storytelling in manga/anime

It is erroneous to pigeonhole all anime as a single genre—the sheer diversity of the subject makes it more a medium of creativity. To take something this broad and reduce it to a narrow definition is futile, and this is why anime storytelling conventions cannot be easily defined.

But as you are no doubt aware as anime fans, the Japanese tend to have a very different perspective on storytelling than the west. This is not only evident in manga and anime, but also other forms of their storytelling such as literature and movies. And while Aristotle's theory of the classic story arc can still be found in most average anime plotlines, the execution is noticeably dissimilar to the west. This is all due to key cultural differences between the east and the west in terms of their historical backgrounds, social customs, and attitudes.

• **Confucianism**
Confucianism is a structure of ethics and philosophy developed from the teachings of the Chinese sage Confucius. It is a complex system of moral, social, political, and religious ideas that has been influential in the history of Asian civilizations. Teachings of humility and respect are core ideas of Confucian teachings, and its resonance can be felt in many aspects of oriental culture including manga and anime. For example, it is very popular for artists to choose a reluctant hero with a degree of self-doubt, believing that such characters emanate a stronger sense of humility and are therefore more virtuous. Family values and respect for the elderly are also key ethics of Confucianism, and the importance of family life is often stressed in anime.

• **Traditions**
Japan is a notoriously proud nation, with a respect for its own history that is unique. The Japanese are big on customs and traditions, and have a very distinctive way of fusing together the ultra-modern and the ancient (If you've ever seen a girl in a traditional Yukata/Kimono talking on a super-hi-tech mobile phone, you will understand this). The honoring of traditions is constantly present in anime; from tea ceremonies to "Matsuri" festivals; from beautiful geisha to sakura blossoms, every celebrated tradition in Japanese culture has been represented in anime, and this is a part of what makes anime unmistakably Japanese.

• War

Manga (in its current form) didn't emerge until the end of World War II, and many observers see the birth of manga as being intrinsically linked to the collective mentality of post-war Japan. Themes of conflict, death, suffering, and sorrow are common in manga and anime (*Evangelion*, *Akira*, *RahXephon*, *Saikano*). This apocalyptic attitude is said to be a direct reaction to the reality of war the Japanese endured during World War II (atomic bombs, the firebombing of Tokyo), a sentiment still palpable in the nation's artistic output and its somewhat existentialist view of the world.

• Education

In many East Asian countries, academia is taken extremely seriously; Japan is one of the strictest. With universities being somewhat more elitist than most of their western equivalents, Japanese student life is not a fun time for most. This is evident in an overwhelming amount of manga/anime based around school life, in which students constantly struggle to get good grades, and spend all their time worrying about failure and the lack of prospects (*Love Hina*, *Chobits*, *Azumanga Diaoh*). The harsh schooling system is something most Japanese have experienced, thus making it a very poignant topic to which much of the public can relate.

Defy conventions!

Anime is frequently dismissed by many onlookers as nothing more than juvenile *otaku* (an overly obsessive form) nonsense, and it isn't hard to see why considering that, superficially, anime seems to endlessly regurgitate the same tired ideas: the little girls with large guns, the harem of cute schoolgirls in tiny skirts, fantasy robot maids, etc. And while these premises can work brilliantly, the greatest anime usually defies these conventions and strives for something greater, relying on strong characterization and a gripping narrative rather than curvaceous cuties. For inspiration, look no further than the works of Satoshi Kon (*Millennium Actress*, *Paranoia Agent*, *Perfect Blue*) and Hayao Miyazaki (*Laputa*, *Princess Mononoke*, *Spirited Away*), both successful anime directors who refuse to conform to conventions.

This is not to say you shouldn't create an anime based on cute girls and big guns; after all, part of the anime doctrine is about frivolous fun! But to make your story stand out in an ever-growing crowd, why not consider designing some unique characters who don't squarely match stereotypes? Or why not tell a story that challenges the audience's expectations?

▼ **Student life** *Themes of awkward adolescence, first love, and friendship are immediately relatable to us all, and have proven to be a popular source of inspiration for manga and anime artists.*

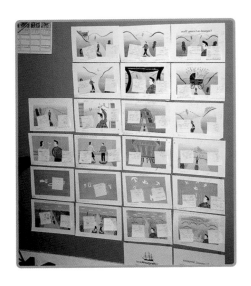

The storyboard is possibly the most important part of any animated movie. It is the bridge between the script and the finished piece. It is where the script is finalized (other than minor dialogue alterations) and the visuals and pacing are established. Every shot in a scene is represented by a single picture, and "camera" moves are decided. In a live-action movie, the storyboard serves more as a loose guide to the action, which can be changed on the day of the shoot, depending upon a variety of conditions; for example, different angles may be tried, or a location may be changed. These changes can be executed quickly, reshot if necessary, and edited to work in the context of the director's vision. In animation, such luxuries do not exist.

▲ *Overview Fixing storyboards to a wall gives an overview of the film-to-be.*

34 STORYBOARDS

- **Preparing storyboards**
- **Language of storyboards**

Making decisions

In 2D-line animation, even more so than with 3D, all decisions have to be made before the work can commence. Every scene has to be planned down to the exact second because, with at least 12 drawings being done for every second of film, you will be saving yourself a lot of needless drawing.

Unlike screenplays, storyboards do not have an industry-standard format. Originally each panel was drawn onto a single card, which was pinned to a large wall-mounted board; hence the name storyboard. These take up huge amounts of space, depending on the length of the animation, but they do allow a whole production team to look at them together. It also makes it easier to adjust the running order or the pacing of the story. Index cards are also a good medium for creating your individual panels. They can be easily filed when not in use, and additional notes can be written on the back. Alternatively, you can divide a sheet of letter paper into panels in the ratio of your intended movie (3:4 or 16:9).

You should be able to get at least six to a horizontal sheet (three across and two down). Leave space at the top for binding. Along the bottom, put the name of the movie, even if it is only a working title, and space to write the page number, scene number, and timing.

To make the storyboards, you will need to break down the script into "shots" or "moments." On your first project, you will probably be the writer/director/animator and already have a clear idea of what you want. At a

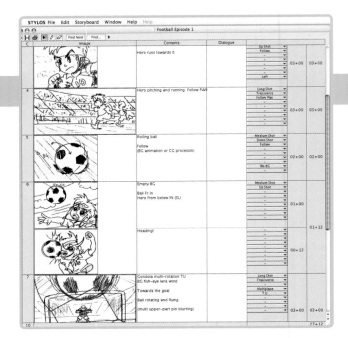

▲ **Dedicated animation programs** *Some programs, like Stylos, have integrated storyboard modules that are linked to the x-sheet and other modules. The drawings can be originated on paper and scanned in, or created digitally within the software.*

professional level, a storyboard artist will work in consultation with the director, who interprets the screenplay and imposes his vision of how it looks. A well-written script will not contain camera moves, but will imply them. For example, if the script says; "We follow Hiro as he walks through the crowd," it could be shown as a tracking shot from the side or from overhead, it could be a following shot or a series of static shots. This is what the director has to decide and show as individual frames on the storyboard, complete with visual instructions regarding movement of cameras, props, and actors if necessary, and any dialogue relevant to the shot.

The storyboards can be drawn with pencils, ink, marker pens, or anything the artist feels comfortable with that clearly conveys the director's concepts to the animators.

CU (close-up) of hand scooping cream from pot. Exaggerated sound, like sucking sound of boot being pulled out of mud. 2 secs (48 frames).

MCU (medium close-up) showing hand moving across face very fast. Exaggerated sound FX. 3.5 secs (84 frames).

CU of face. glow SFX. Wind chime/sparkle sound FX. 2.5 secs (60 frames).

ELS (extreme long shot) Still frame. Crowd noise sound FX. 3 secs (72 frames).

LS (long shot) low, dutch angle. Crowd noise FX. 1.5 secs (36 frames).

LS dutch angle. Doors swing open. Wind sound of doors opening. Crowd noise FX stops suddenly. 3.5 secs (84 frames).

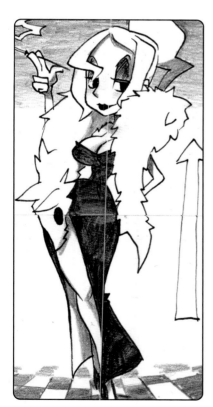

MS (medium shot). Slow tilt up from feet to top of head. Big spender-type music. Low murmur of crowd. 7 secs (168 frames).

MS. Camera pans right following as she moves along crowd of admirers. Sound and music continues. 5 secs (120 frames).

Storyboards for a short animation *This has sound effects but no dialogue, using a 12-panel sheet created on a computer. Each frame contains notes relating to movement, camera shot, sounds, and running time.*

ECU (extreme close-up) of face melting. Sound of plastic blistering under heat. 1.5 secs (36 frames).

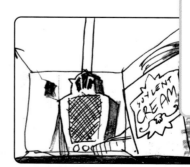

CU of perfume bottle tracking back to show cream jar in situ. Silence. 3 secs (72 frames).

Sound effects are written in the first column with other notes

Camera directions are marked by arrows and annotations as to the type of shot

Customized storyboard format *This three-column format has one column for notes and directions, one for visuals, and the third for dialogue. It is not really necessary to make such detailed drawings, although they will impress a prospective backer.*

Animatics

Once you have drawn all your storyboards and calculated the timing of each shot and scene as best you can, you need to see if it will work in practice. For this you have to make an animatic. This is a video version of the storyboards with the dialogue added.

If you have access to a camcorder and tripod and used index cards for your storyboards, you can shoot the frames and record the dialogue in real time. If you are prepared to do all the voices yourself, you won't even need to call in your intended voice actors. You simply pin the cards to a board, make sure they are properly framed, and run the camera for as long as each frame requires. Most DV cameras will display timecode measured in mm:ss:ff (minutes:seconds: frames) so you can accurately time each shot and record the dialogue at the same time. You may prefer to record the voiceover separately and simply concentrate on recording the images. Alternatively, you can use a digital still camera and import the

images into a simple editing program (such as iMovie on a Mac or MovieMaker on Windows) then accurately sequence them along the timeline and add the voiceover. As an artist you are more likely to have a scanner attached to your computer, so you can use the same method described for the digital still camera.

Whichever method you use to capture the sound and images, the important thing is to play it back to check for running time and pacing. Running time is objective; it either fits the intended length or it doesn't. Pacing, if scenes are too long or too short, is more subjective and may require the opinions or feedback of others but, ultimately, is the director's decision. Once you are happy with the storyboards and animatic, you can start transferring all the information to an x-sheet (exposure sheet, also known as a cue sheet or dope sheet) to begin the process of drawing the hundreds or thousands of frames needed to make your anime.

The x-sheet

The x-sheet is a vital part of cel animation, even if you intend to work digitally. It lists every frame that is drawn, or needs to be drawn, the dialogue and mouth shapes, and any camera instructions. Creating a precise x-sheet relies on accurate storyboards and animatics. The timings decided at those stages will determine the number of frames to be drawn. It is vital that the director knows how long a movement takes, at the animatic stage, because what he or she perceives with the storyboard stills may not translate to actual frame-by-frame movement. Most digital animation programs have their own version of the x-sheet built-in to make the process easier, especially for people coming from traditional animation. The digital x-sheet is more flexible as it automatically updates if frames are added or deleted.

A note about a sound effect that has to be added at the editing stage.

The dialogue is written phonetically, sometimes with mouth shape sketches, to match the timing. This sheet is set up for shooting on film.

The cel numbers are written to correspond with each frame. Layer 2 is being shot "on twos," which means each cel is photographed twice. This layer has the most movement —the mouth, eyes, and perspiration.

The camera instruction tells the camera operator to shoot an area 8 fields wide at the center of a 15-field guide. This is the equivalent of a medium close up. The camera can then zoom out later in the sequence.

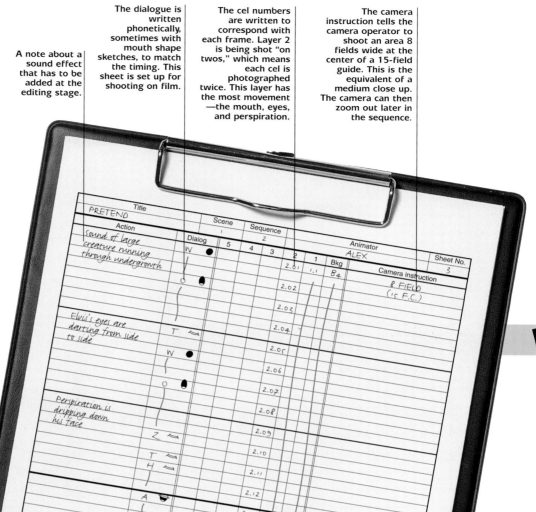

Using software to create animatics

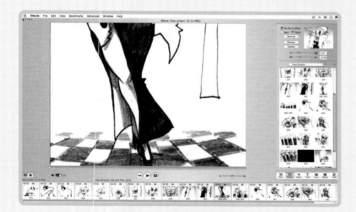

▲ **Apple iMovie** *This comes with all Apple computers or as part of the iLife package and will import still images or video footage to make an animatic. Still images can be taken with a digital camera or a scanner, and imported into iMovie through iPhoto. A voiceover track can be recorded directly into the software.*

▲ **Running time** *You can adjust the running time of each still image in iMovie simply by double-clicking the image in the timeline, and adjusting its duration, which is measured in seconds and frames. The frame count is 25 fps for PAL and 30 fps for NTSC.*

Writing a script or screenplay for your animation is the first—and possibly most important—step to realizing your story idea. The screenplay puts the story into a format that can be utilized and understood by everyone involved in the project, from the voice talent to the artists. A screenplay has its own particular format and style that differ from writing novels and it is important to learn and understand these.

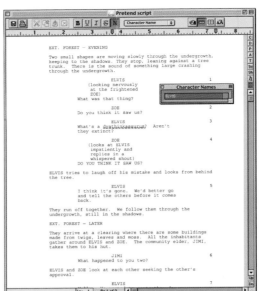

Using software

The working window of Screenwriter 2000 is not dissimilar to a standard word processor, except it has preset (and editable) writing guides (known as style sheets) and shortcuts to make the job of writing and formatting an anime a lot easier. The numbers on the right-hand side indicate each piece of dialogue.

SCRIPTWRITING

- **Writing a script**
- **The importance of dialogue**
- **Preparing your script to an industry-recognized format**

Format

If you are the writer, director, and animator for your project, then using the standardized screenplay format is not that important, since you are the only one who needs to understand what it says. However, if you want to be taken seriously as a professional, writing to the industry standard is vital—especially if you want to try to sell your script or get funding for your project.

Using the correct format for your screenplay is probably more important than in any other writing discipline, because the people whom you need to see it will only look at it if it is done in the accepted way. Luckily, you don't need any dedicated or special software, although there are two programs (Final Draft and Screenwriter 2000) that are used industry-wide, and that format for you as you type. Because these packages are essentially glorified word-processors, you can use any word-processor that allows you to set margins and tabs; if it can create and save style-sheets, so much the better.

Form

As with all disciplines and arts, learning the correct methods not only makes working that much easier, but also shows you have taken the time to learn and therefore gives you more credibility. However, there is a lot more to writing a good script than using the correct layout. There are certain conventions that have to be followed, and—while they might not all apply to animation—it is just as easy to write as if it were a live-action movie and then make any alterations later. One of the great advantages of scriptwriting is that you don't need to write masses of description. You are writing for a visual medium and a lot of what you write will be little more than notes about the setting or the action. These just serve as a guide for the director, so, if it is you, you know what you plan to do anyway. If it is someone else, the chances are they will ignore most of it to give the story their own vision. The important thing is to convey enough information for the storyboard artist to create the initial concepts.

Dialogue

The bulk of your screenplay will probably be dialogue, unless you are making a silent movie, but even that requires a script. Writing good, natural dialogue is what separates a good writer from a great writer (*Paranoia Agent* and *Gantz* are great examples). To write good dialogue, you have to listen to people talking: in trains, in bars, at the mall, everywhere—and also in movies.

Apart from listening, you should also read a lot of scripts. Bookstores sell screenplays of popular movies, although these can often be transcripts of the finished movie rather than the final, or shooting, script. They are usually not printed in the standardized format, either. There are several websites that have proper screenplays, which can be downloaded as PDFs, and are licensed for educational use, which means that you can read and study them, but not perform or reproduce them (see panel for links).

Once you get the basic idea of how a screenplay works, start writing. It is the only way to truly get a feel for it. Don't let not knowing the right formatting be your excuse for not doing it. It can easily be corrected later, because you will go through several drafts; if you don't, you are either a genius, or fooling yourself. So start getting those words down on the page.

Check these out

www.finaldraft.com Website for Final Draft software.
www.screenplay.com Website for Movie Magic Screenwriter software.
www.simplyscripts.com Free, downloadable scripts.
www.screentalk.biz Website of Screentalk magazine with lots of free scripts to download.

Scene heading: Tells where and when the scene takes place. Set in capital letters.

Action: What is happening in the scene. This is written in the present tense.

Formatting a script

Because all scripts were originally written on typewriters, their formatting has been standardized into a very simple style. Even on computers, the Courier typeface is used with single line spacing (12 pt on 12 pt leading), and indents are calculated from the edges of the paper, as shown.

Parenthetical: This is a stage direction. It is used more in animation than in live-action scripts.

Character name: Set in capital letters on a new line with a blank separating it from the previous action or character.

Dialogue: The spoken words.

```
EXT. FOREST — EVENING

Two small shapes are moving slowly through the undergrowth,
keeping to the shadows. They stop, leaning against a tree
trunk. There is the sound of something large crashing
through the undergrowth.

                    ELVIS
               (looking nervously
                at the frightened
                ZOE)
          What was that thing?

                    ZOE
          Do you think it saw us?

                    ELVIS
          What's a dyathinkasaurus?  Aren't
          they extinct?

                    ZOE
               (looks at ELVIS
                impatiently and
                replies in a
                whispered shout)
          DO YOU THINK IT SAW US?

ELVIS tries to laugh off his mistake and looks from behind
the tree.

                    ELVIS
          I think it's gone.  We'd better go
          and tell the others before it comes
          back.

They run off together.  We follow them through the
undergrowth, still in the shadows.

EXT. FOREST — LATER

They arrive at a clearing where there are some buildings
made from twigs, leaves and moss.  All the inhabitants
gather around ELVIS and ZOE.  The community elder, JIMI,
takes them to his hut.

                    JIMI
          What happened to you two?

ELVIS and ZOE look at each other seeking the other's
approval.

                    ELVIS
          Well... We wanted to go to the edge
          of the world, just to see where it
          finished but we didn't find it
          because... because...

                    ZOE
          There was a beast there that
          entered our world.
```

The characters are the most important element of any story, whether it is animated or printed. They are the element that the audience identifies with; great characters will retain the audience's interest. But how do you come up with convincing characters? Developing characters isn't just about drawing people with great hair and fantastic costumes. Your characters need to have a personality that viewers can identify with. In western scriptwriting, a lot of emphasis is put on the use of archetypal characters, and what is known as "the hero's journey." This is based on the research done by C.G. Jung, who said that archetypes are the primordial models upon which we, as humans, are all fashioned. He applied this idea to our traditions of storytelling. This research was further developed by Joseph Campbell in his seminal book, *Hero with a Thousand Faces* (1949), and distilled for scriptwriters by Christopher Vogler in his book *The Writer's Journey* (1992).

40 CHARACTER DESIGN

- **Build character profile sheets**
- **Sketch ideas first**
- **Draw turn-around guides**

Develop original characters

While archetypes will serve as an excellent foundation for your characters and story, giving them universal appeal, anime has its own cast of regular character types that appear in its many genres. Some are shown on the following pages, with ideas and techniques for creating not only a look for the characters but also how to develop a personality for them.

One of the best ways of developing a personality for your creation is to use a character profile sheet (see opposite). This becomes a dossier for the character, where you write their complete history as if they were a real person: their family and school or work details, their likes and dislikes; anything you can think of that will make them more real in your mind, even if you never use the information in your animation/story. You can even conduct a role-play interview with them; after all, animators are often called actors with pencils.

As you can see, this is a complex subject that requires further reading to fully understand.

The formula

The premise behind the hero's journey is that every story follows a definite pattern, with specific archetypal characters appearing at key moments. The interesting thing with using this formula is that the different archetypes can be amalgamated into a single character, if necessary, because these are all aspects that exist in every person. Essentially, we are all the heroes of our own stories and we play other archetypal roles (to lesser and greater degrees) in the stories of everyone we meet and interact with.

The most common archetypal characters are:

the hero (the protagonist of the story)
Luke Skywalker, Frodo, Hercules, Spider-Man, Neo

the mentor (the wise person and hero's guide)
Obi-Wan Kenobi, Gandalf, Morpheus, Merlin

the threshold guardian (to test the hero's resolve)
Shelob, Sirens

the herald (to assist and announce the hero)
Hermes, Lois Lane, Sam Gamgee, Trinity, Sancho Panza

the shapeshifter (to test and confuse the hero)
Mystique, Agent Smith, Gollum, Spike, Mata Hari

the trickster (comic relief)
Bugs Bunny, Br'er Rabbit, C3PO

the shadow (the bad guy)
Darth Vader, Voldemort, Saruman

◄ **Hybrid ideas**

Hybrid ideas take the best of the anime style of design and combine it with identifiable aspects of western entertainment that will appeal to more western tastes. Fantasy and science fiction are two genres that work well with anime, as in characters like the one opposite.

Animator's tip: Observe real life

A useful method for developing characters is observation. Sitting in public places such as coffee shops, shopping malls, or transport terminals and partaking in people-watching is a fruitful occupation. Listening to strangers' conversations will give you plenty of fresh material. Take a small sketchbook, notebook, or digital camera to make notes and visual references. Just be discreet about how you do it!

Character profile sheets

These supply all the details needed to create a realistic character. An animator is not always a writer (and vice versa), so the information on the sheet is what the artist will use to create a character's appearance. The writer should give an accurate account of what the character looks like, with details like height, hair and eye color, clothing, and so on. The writer's descriptions will help the animator develop facial expressions and body movements. If the artist and writer are separate people, they must agree on the final outcome of the character's appearance, and both give feedback and input. If you are a one-man band, this will be easier, but using a character sheet is still helpful for collating your ideas.

► **Lilith's profile sheet**

The writer gives very specific details about the character's appearance and clothing. It is interpreted in an obviously shojo anime style, where a western artist may have used a much darker, grungier look for the clothes and expressions.

Name: Lilith

Nicknames: Lili, Lilis, Riri, Ririsu

Gender: Female

Age: 16

Date of birth: 17 December

Height: 159 cm

Weight: 55 kg

Hair color: Pinkish-red (depending on the light)

Eye color: Red

Clothes: Casual, punk/goth style, purple striped socks/arm warmers, key on necklace

Favorite colors: Red, pink, purple, black, white

Occupation: High school student

Favorite subjects: Literature, art, philosophy

Likes: Mysterious things, gothic fantasy stories, the sky, shiny objects, birds (especially doves), desserts

Dislikes: Garish colors, loud noises, obnoxious and arrogant people

Powers/abilities: Magical powers from the key around her neck. The key can undo almost any lock.

Personality traits: Lilith is a strong character, but she is never loud or aggressive. She remains quietly assertive no matter what tribulations afflict her.
Always vigilant and aware of her surroundings, she knows how to behave in a dangerous situation, which ensures her safety.
Underneath her robust exterior lie some of her weaknesses. She can be quite naïve, and has had her trust in someone betrayed, so she has become cautious and distrustful of other people, making her appear very aloof.
When something really pains her, such as the loss of her parents, her natural reaction is to shed tears of sadness.
Highly independent and reclusive. She feels at peace when she is by herself, and only speaks when necessary.
Without a specific goal to aim for, Lilith lives through each day searching for a purpose.
Unravelling the mysteries of the key around her neck may provide her with the answers she seeks.

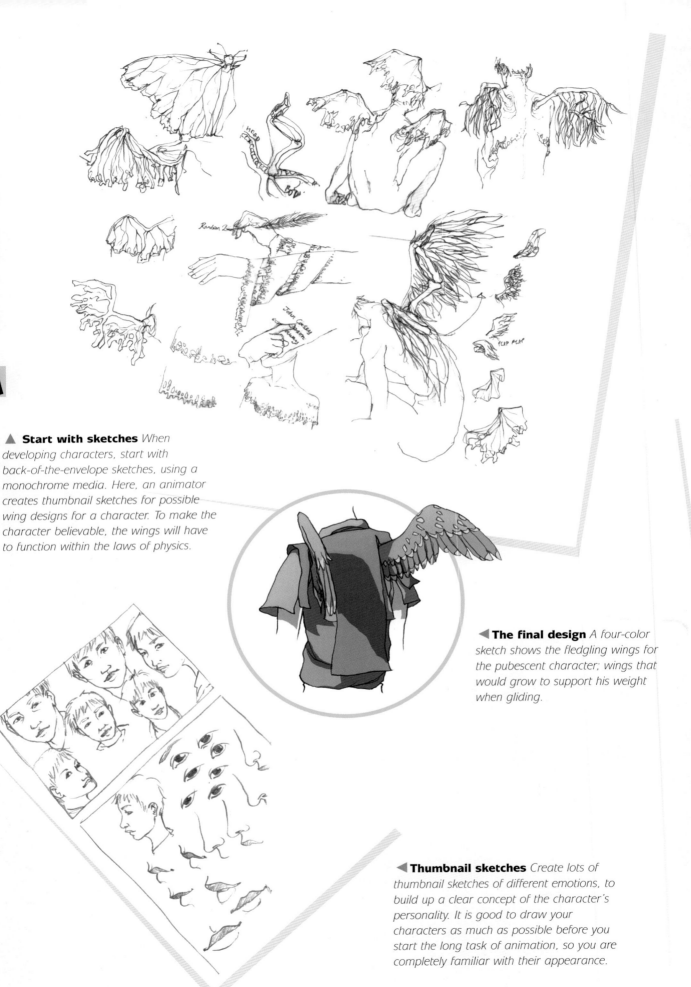

▲ **Start with sketches** *When developing characters, start with back-of-the-envelope sketches, using a monochrome media. Here, an animator creates thumbnail sketches for possible wing designs for a character. To make the character believable, the wings will have to function within the laws of physics.*

◄ **The final design** *A four-color sketch shows the fledgling wings for the pubescent character; wings that would grow to support his weight when gliding.*

◄ **Thumbnail sketches** *Create lots of thumbnail sketches of different emotions, to build up a clear concept of the character's personality. It is good to draw your characters as much as possible before you start the long task of animation, so you are completely familiar with their appearance.*

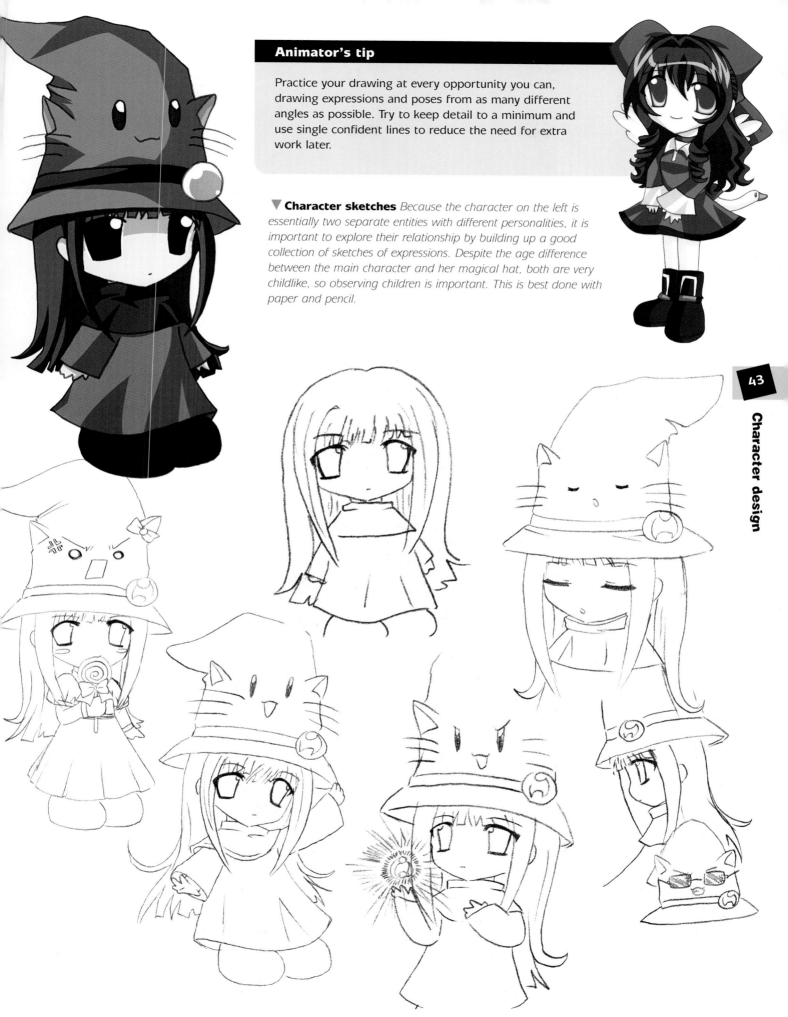

Practice your drawing at every opportunity you can, drawing expressions and poses from as many different angles as possible. Try to keep detail to a minimum and use single confident lines to reduce the need for extra work later.

▼ **Character sketches** *Because the character on the left is essentially two separate entities with different personalities, it is important to explore their relationship by building up a good collection of sketches of expressions. Despite the age difference between the main character and her magical hat, both are very childlike, so observing children is important. This is best done with paper and pencil.*

43

Character design

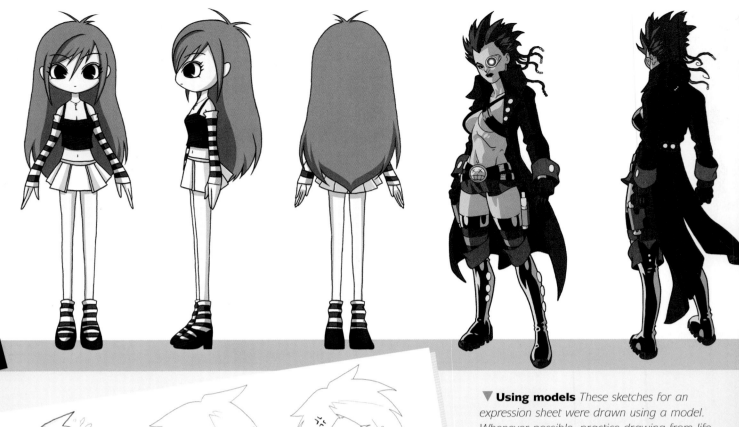

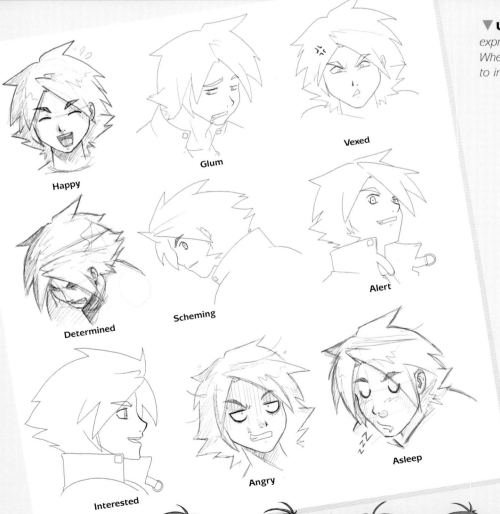

Happy

Glum

Vexed

Determined

Scheming

Alert

Interested

Angry

Asleep

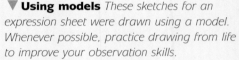

▼ Using models *These sketches for an expression sheet were drawn using a model. Whenever possible, practice drawing from life to improve your observation skills.*

◄ ▼ Expression sheet *Apart from writing a complete personal history of your character, whether you use it or not, you should also explore a full range of emotions as facial expressions. These may help to trigger off a facet of the character's personality you had not considered previously.*

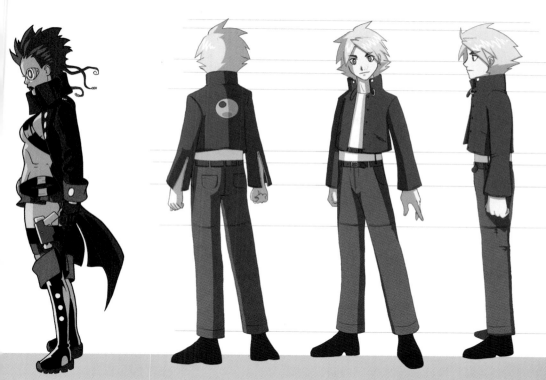

Turnaround sheets *The turnaround is an essential part of the design process, especially for 2D animation. Guidelines help ensure proportions are accurately transferred from one angle to the next. If the character has several changes of clothes, turnarounds should be made for all of them. Three views are the minimum you should draw. An opposite side view and a three-quarter view are useful as well.*

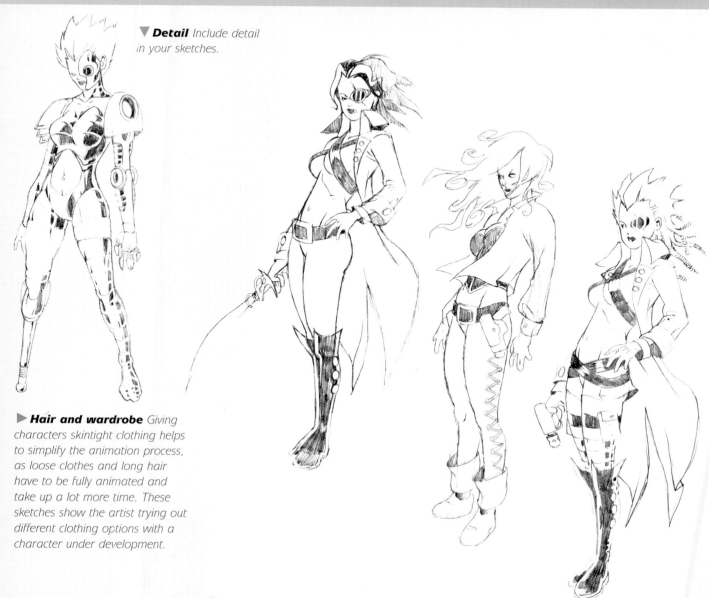

Detail *Include detail in your sketches.*

Hair and wardrobe *Giving characters skintight clothing helps to simplify the animation process, as loose clothes and long hair have to be fully animated and take up a lot more time. These sketches show the artist trying out different clothing options with a character under development.*

Essential Animation Skills

Although the vast majority of today's animation is created digitally, basic drawing and animation skills are still required. Computers can reduce the amount of work, especially for repetitive or labor-intensive tasks like painting, but they cannot replace essential drawing skills. The following pages cover a variety of basic animation techniques that can be applied to any 2D animation, whether it is hand-drawn on paper or input digitally with a graphics tablet and stylus. By mastering methods such as key frames, walk cycles, facial animation, lip-synching, and sound, as well as easy ways of achieving the same effects with minimal work, you will be able to create professional-looking animations.

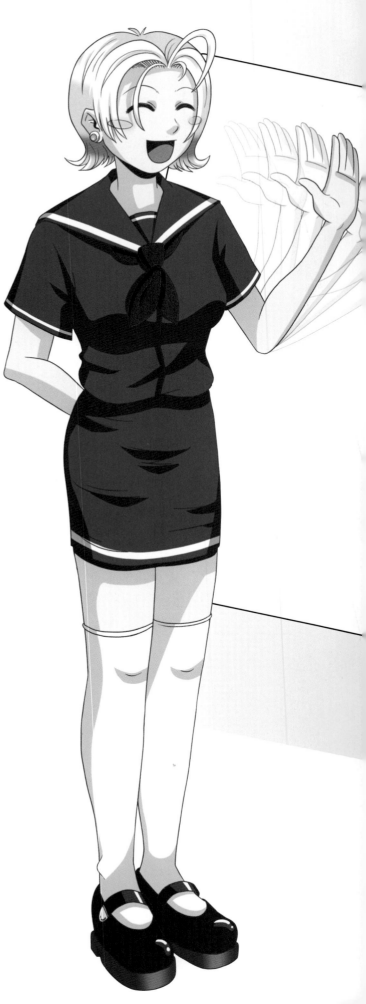

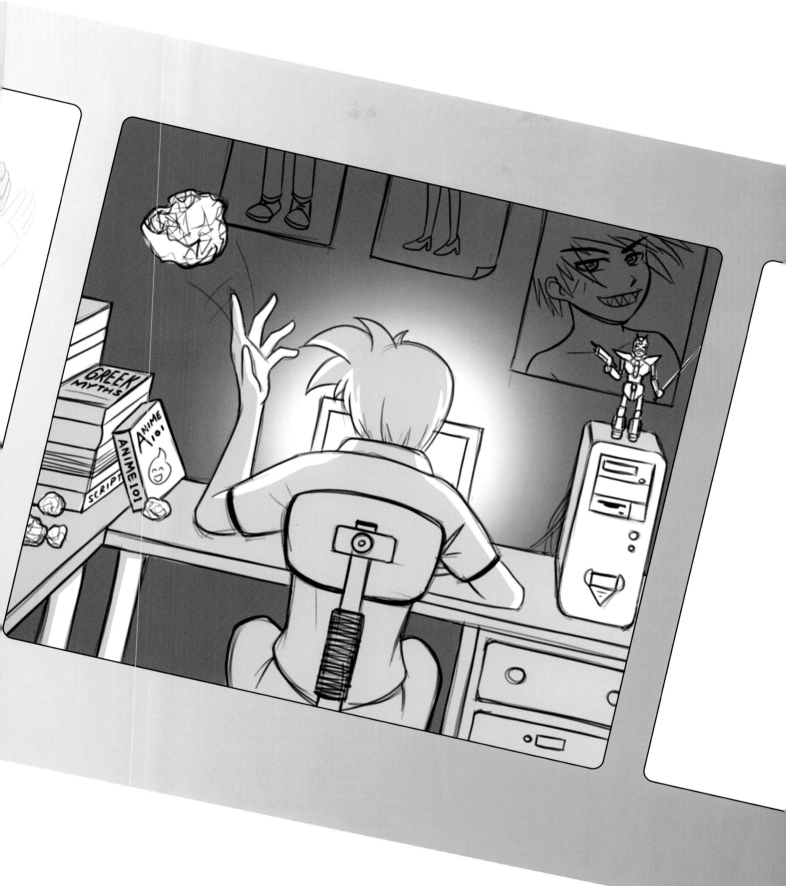

■ **The basic production methods**
for animation have not changed much over the past century, but many of the tools involved have evolved considerably. The integration of computers into the workflow has reduced labor in certain areas of production and allowed more time and energy to be focused on the animation itself. Whatever method of production suits you best, be sure to choose the correct tools for the job.

■ **Getting the most from your tools**

TOOLS AND MATERIALS

Pegboards and animation paper

When producing animation on paper, you need to use a pegboard. Animation paper typically has three holes punched in it to make sure it aligns perfectly with the previous and subsequent frames. By placing the paper on a pegboard, it is possible to flick between animation frames to ensure a smooth transition.

It is common for animators to fasten a pegboard to their flatbed scanner to guarantee each frame of animation is perfectly aligned when digitized. This speeds up the scanning process and avoids unnecessary errors or adjustments. Professional studios use scanners with sheet feeders (like on photocopiers) and software that automatically aligns the peg holes.

Pencils and erasers

Mechanical pencils are recommended for animation work because they are clean and reliable, with a consistent stroke. You should opt for the softer grade pencils, as a lot of adjustments may have to be made to each image to ensure the animation is perfectly smooth, which means a lot of erasing. Soft putty erasers are a good choice, since they do not leave residue on the paper.

Some animators use colored pencils for certain parts of their frame, such as marking the "cel-shaded" area of the image. This is picked up later during scanning and is used as a guide when coloring the frames.

Lightboxes

The lightbox is an essential tool for producing animation on paper. By placing the paper on the lightbox, it is possible to see several frames of the animation at once, making it easy to predict where the following image should be. Pegboards are used here to ensure each frame is aligned correctly. Lightboxes designed for animators feature a rotating disc that makes it easier to draw when the paper is fixed to the pegboard. Animation software for computers often emulates the use of a lightbox with a function called "onion skinning" (see page 60).

Animation cels and paints

Traditionally, animation is produced on sheets of clear acetate called cels. The line art from the individual frames is copied onto transparent sheets and paint is applied to the rear side of the image. This technique has become less common with the advent of digital animation, but it is still used by many animation production companies.

Digital still and video cameras

Digital cameras have a number of useful purposes when producing animation. First, they can help provide reference material—you can film movements of yourself or a friend from different angles and then play it alongside your animation. It is easier than using a mirror and doesn't have to be perfectly lit.

Secondly, the footage can be used as the basis for the 2D animation itself, using a technique known as "rotoscoping." Rotoscoping involves tracing the movement of a person from existing footage to create very accurate 2D animation. It was originally done by projecting the frames of a film through a lightbox, but modern digital solutions make it much easier.

Finally, digital still cameras are a great way to get reference images for backgrounds, environments, household items, and any number of other objects. Shoot the scenes and objects from as many different angles as possible to take full advantage of the medium.

Computers and software

Computers are now the mainstay of anime. They have made it much easier to produce professional-looking animation, even for first-time animators. Software like Flash and Toon Boom Studio has simplified the process and made it easy to create a short anime to show on the web. Nearly all animation software is available for both Apple Macintosh and Windows machines, so your choice of computer will be down to personal preference and budget. A large monitor and fast processor are important, so an Apple iMac would be an excellent choice, for instance.

The most important peripheral to get is a graphics tablet. These come in a variety of sizes and prices, with Wacom being the market leader. This tool will allow you to draw directly into the software, as if you were using a pen, and is a more natural way of working.

It is an age-old lesson in art theory that everything we see can be broken down into simple geometric shapes that make up the very essence of their form. The human body is a complex structure, but if you think of it as a collage of spheres and cylinders you will find it much easier to mentally digest and subsequently draw. This technique of sketching out a "mannequin" has always been synonymous with comics/mangas and animation, and is very helpful in conveying core ideas before finalization.

Break figures into basic shapes

Keep detail to a minimum

2. Rough sketch

Create a new layer on top of the mannequin and do a rough sketch over it. Details are not important at this point, just treat it as a pencil sketch and get the basic ideas down. To get a nice pencil feel you may wish to reduce the flow or opacity of the brush to 50%.

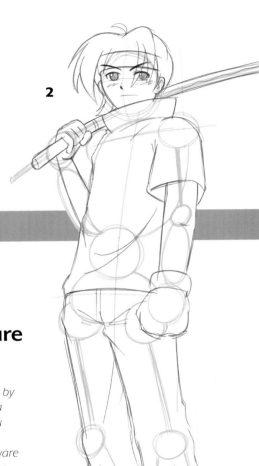

Drawing a male figure

1. Basic-shapes mannequin

You may wish to create stages 1 and 2 by hand, and then scan the sketches into a computer for inking and coloring. If you are working on a computer, open Photoshop (or the digital imaging software of your choice) and start by outlining the character pose using basic shapes. Since the human body is relatively curvaceous, it is a good idea to stick to using simple circles and oblongs to construct the overall shape. Bear in mind that you are building a male character and make sure that the proportions are set accordingly, with wide shoulders and straight hips.

Line of action

Animator's tip: The line of action

The line of action encapsulates the dynamics of a pose—it's an imagined line which goes inside the figure. For some animators, it is the first mark they make when drawing a moving figure. The body parts are hung off this line and reflect its direction.

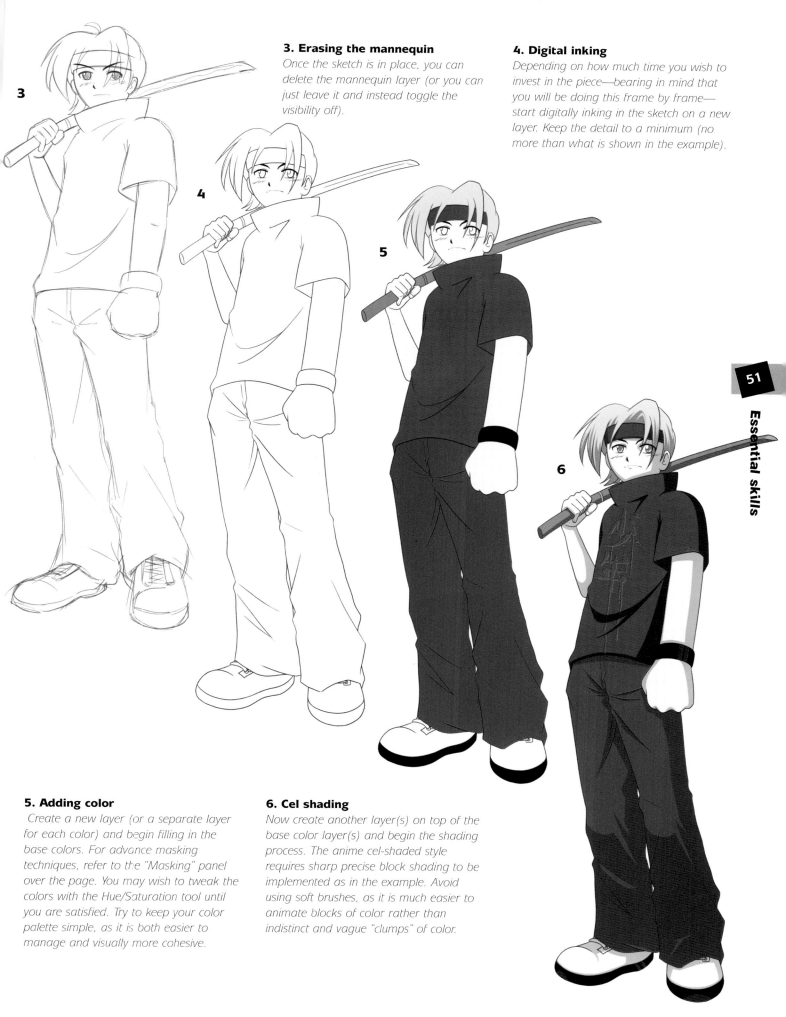

3. Erasing the mannequin

Once the sketch is in place, you can delete the mannequin layer (or you can just leave it and instead toggle the visibility off).

4. Digital inking

Depending on how much time you wish to invest in the piece—bearing in mind that you will be doing this frame by frame—start digitally inking in the sketch on a new layer. Keep the detail to a minimum (no more than what is shown in the example).

5. Adding color

Create a new layer (or a separate layer for each color) and begin filling in the base colors. For advance masking techniques, refer to the "Masking" panel over the page. You may wish to tweak the colors with the Hue/Saturation tool until you are satisfied. Try to keep your color palette simple, as it is both easier to manage and visually more cohesive.

6. Cel shading

Now create another layer(s) on top of the base color layer(s) and begin the shading process. The anime cel-shaded style requires sharp precise block shading to be implemented as in the example. Avoid using soft brushes, as it is much easier to animate blocks of color rather than indistinct and vague "clumps" of color.

Essential skills

Drawing a female figure

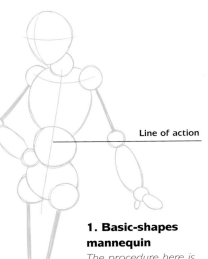

Line of action

1. Basic-shapes mannequin

The procedure here is essentially no different than that of drawing a male figure. Sketch out the mannequin in your desired pose. This example depicts a slim, model-like character, posed as if walking down the catwalk.

2. Rough sketch

Create a new layer on which to lay the rough sketch. Avoid spending too much time fussing over details at this stage—just try to get a good sense of the overall composition.

3. Erase mannequin

Delete the mannequin layer (or leave it and toggle the visibility off).

4. Digital inking

Begin digital inking. Avoid too much detail, as the higher the detail the harder the character will be to animate later. The detail shown in this example is probably too much for long-haul animation—you may want to counter this by reducing the amount of crease marks in her clothing and the detail of the hair. However, as a still shot, a highly detailed frame like this can be visually arresting.

5. Add color

A limited color palette has been used. The simple combination of pink, black, and white is effective and appealing.

6. Basic-shaped mannequin

Apply cel shading and finishing touches to complete the piece. Keep details to a minimum.

Masking

Using a "mask" is not compulsory to the cel-shading process, but it can be a very handy technique to employ in order to raise efficiency. Essentially the virtual equivalent of masking tape, the mask tool in Photoshop (or any other advanced imaging software) can help section out specific areas of the image permanently, saving you the trouble of reselecting/deselecting over and over while applying cel shading.

1. *Choose the "Magic Wand" tool and select the desired area to cel shade. When the selection is made, go to the top menu and choose "Select>Modify>Expand" and apply a 1–2 pixel expansion. This is important because the magic wand does not go right to the edges of the line art. By expanding the selection, you are making sure that the colors you later implement will bleed right to the edges. It should be noted that this method is only applicable to selections that are totally sealed off. If there is a gap in the line art, the magic wand will not accurately make the selection. In this case, simply use the "Polygon Lasso" tool to make the selection manually instead.*

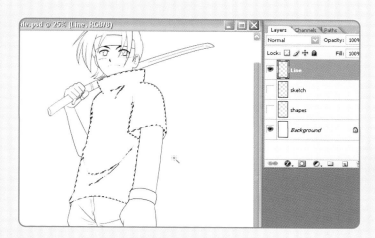

2. *Create a new layer underneath the line art that is to be the colored layer. With the desired area selected, click on the "Add Layer Mask" button located at the bottom of the "Layers" window (a black box with a white circle in its center). Now the area is sectioned off by the mask and anything outside the mask is immediately non-visible. The exact area of the mask can be seen by pressing the Control and Backslash keys together.*

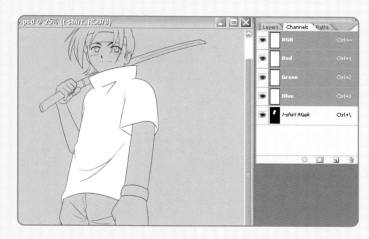

3. *Add in the desired color and let the mask do the rest. You may need to amend the mask slightly at this point, since the magic wand tool is fallible and might not pick up the tight corners very well. The mask can be modified by selecting the mask property of the relevant layer (the black rectangle to the right of the original layer image). Now you can add to the mask and cover up more of the image by using a pure black brush, or delete some of the mask by using a pure white brush. Any tones in between will result in a mask of half opacity.*

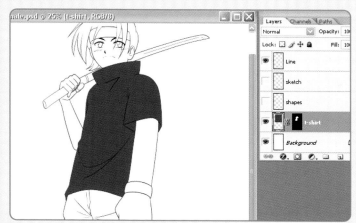

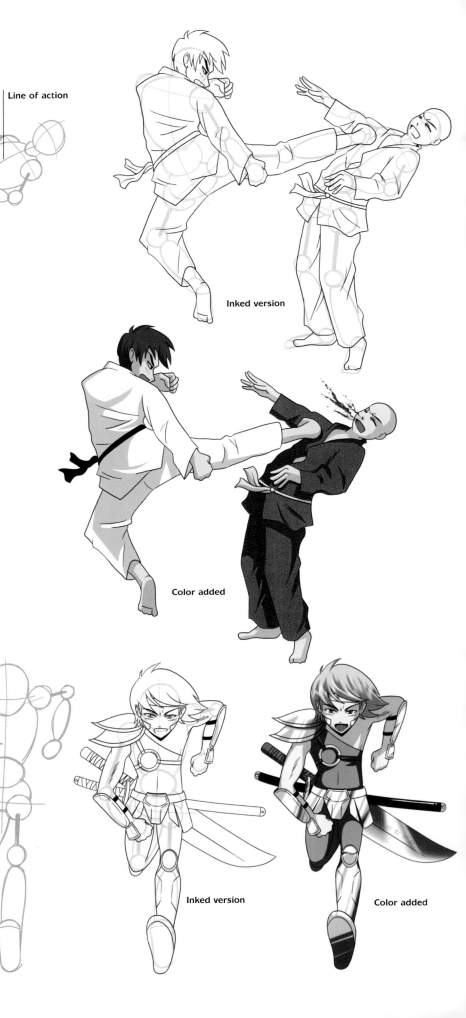

Line of action

Line of action

Line of action

Inked version

Color added

Line of action

Inked version

Color added

Karate fight

This is the basis for a complex action sequence. Sequences with such emphasis on full body movements and body interaction should always be animated in mannequin form first. This will not only allow changes to be made more easily, but will give you a better overall view of the animation's fluidity.

Running hero

Action poses and sequences are generally complex to realize, and this is where the application of a mannequin sketch can help. In this example, one frame of a run sequence is depicted, showing the character in mid-stride. Breaking a complex pose such as this down to basic shapes can really help you get started, and allow you to ensure the character's anatomical correctness at every stage.

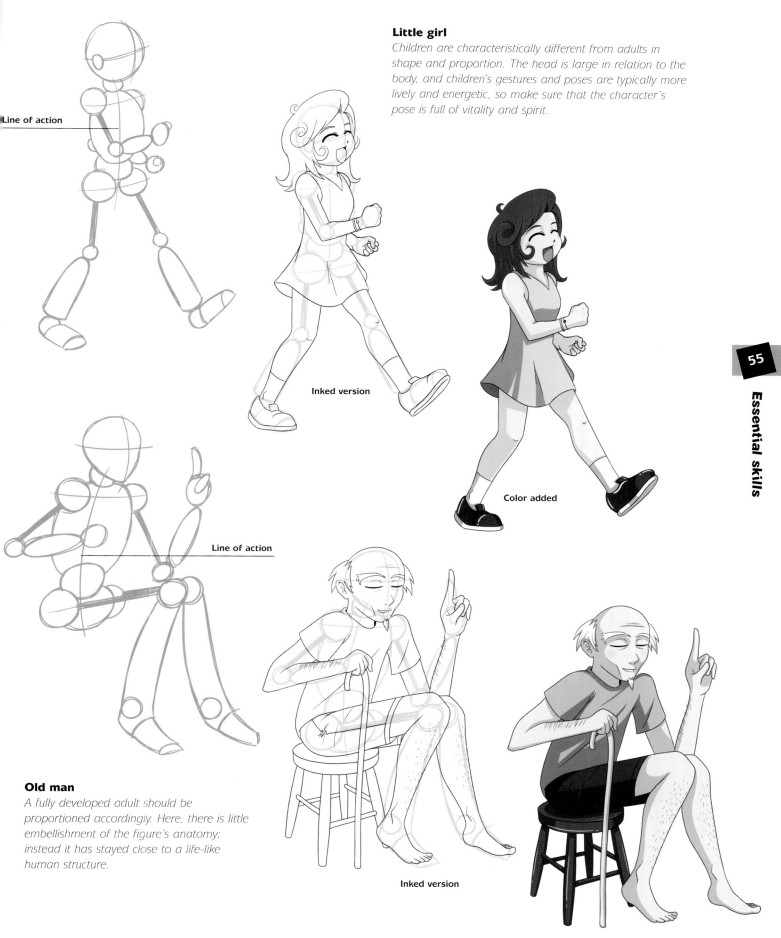

Line of action

Little girl

Children are characteristically different from adults in shape and proportion. The head is large in relation to the body, and children's gestures and poses are typically more lively and energetic, so make sure that the character's pose is full of vitality and spirit.

Inked version

Color added

Line of action

Old man

A fully developed adult should be proportioned accordingly. Here, there is little embellishment of the figure's anatomy; instead it has stayed close to a life-like human structure.

Inked version

Color added

Essential skills

■ **A "keyframe"** is a still image that represents a single frame of an animated sequence. In terms of traditional hand-drawn animation, every frame could be described as a keyframe. The term was originally derived from a technique known as "keyframe animation." This method involved the lead animator producing only the keyframes of a sequence, the ones capturing the crucial or peak moments of the action (e.g. the beginning, middle, and end of a walk cycle). These would then be handed over to an apprentice who had the laborious task of adding substance to the existing framework by filling out the in-between frames in a process known as "tweening," which is short for "in-betweening."

Although software will not automate complex 2D line art animation, the kind that make up the majority of anime productions, keyframe animation and tweening are essential techniques to understand, and absolutely invaluable to animating in 3D.

56 KEYFRAMES

■ **The importance of keyframes**

■ **Keyframes and timing**

▶ **Motion** *These keyframes map out the motion of the figure turning her head and looking toward the camera.*

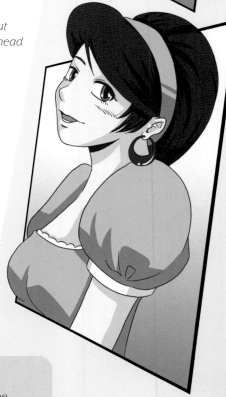

Keyframes in "frame-by-frame" animation

The tradition of hand-drawn "frame-by-frame" animation is a laborious one, but absolutely vital in achieving that illustrious anime look. Understanding the principles of keyframe animation can help lighten this burden by breaking the work down into manageable stages.

Establishing a few solid keyframes that map out the crux of the animation will give you a better overview of how the sequence should go. This will allow you to plan out entire scenes very quickly and efficiently, without having to commit to a mountain of drawings.

Once the keyframes have been set, it is much easier to work out the timing of the animation by simply tweaking keyframe positions. This freedom to adjust timings would not be possible without keyframe animation.

▼ **Telling the story** *The keyframes tell the story by showing the key points in each movement that the characters make. If these frames were run, the sequence would be jerky (and short!), so in-between frames must also be prepared.*

①

②

③

④

⑤

⑥

Smooth operator

The smoothness and overall quality of animation is largely determined by the number of frames you decide to place between your keyframes. The more frames, the smoother and more detailed the animation will inevitably be. As you have probably gathered by now, frame-by-frame animation is an extremely labor-intensive process, and it is not always practical to lavish on every sequence the attention and detail you would like it to have. Therefore, it is not only advisable but also essential that you strike a balance between quality and effort; after all, an efficient animator is a smart one!

Budget vs. detail

In the anime industry, deadlines can be extremely tight, with studios often working on a limited budget. Cutting corners is common practice, and this especially applies to most weekly TV series that have incredibly fast turnaround rates. Feature-length anime movies usually have the freedom that comes with bigger budgets and looser schedules. Blockbusters like *Akira*, *Ghost in the Shell*, or any Studio Ghibli production (*Spirited Away*, *Princess Mononoke*) are testaments to this, sporting higher frame counts and inconceivable levels of detail.

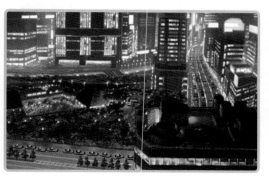

The level of detail in just this one frame from Ghost in the Shell: Stand Alone Complex, *is astounding.*

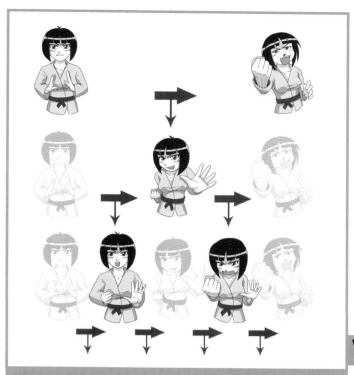

Principles of tweening

Start In this karate-punch sequence, the motion begins with a stance and ends on a punch. On the top row are two keyframes mapping out these poses.
Interim frame With the start and finish in place, we can now begin the manual tweening. Start by articulating the middle point, as seen on the second row. Now you have three frames of animation: the stance, the preparation for the punch, and the punch.
Additional frames Repeat the process by adding two more frames in the middle points of the existing three frames, as on the bottom row. The animation is taking shape, and the flow of the sequence is becoming apparent. Another four frames should complete the movement.

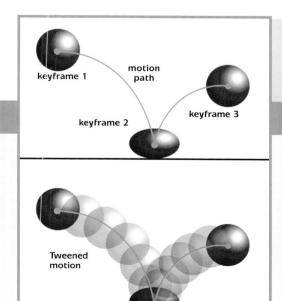

◀ **Keyframes and tweening** *This bouncing ball sequence illustrates the theory of using keyframes and auto motion-tweens.*

Digital tweening

Software programs, such as Macromedia Flash or any other worthwhile animation package (see page 108), incorporate some very sophisticated automatic tweening features, which offer many ways to help you with your animation. The tutorials on the following pages will show you how to perform some of the most common tweening operations in Flash.

Motion tween

One of the most useful tweening techniques is the motion tween, which automates simple tasks such as moving, scrolling, and rescaling objects. This example shows how to create a simple path-guided motion tween.

1 *Create or Import the object you wish to motion tween. To draw a new object, select "Insert > New Symbol," which opens the New Symbol palette. Give the object an appropriate name and select "Graphic" under "Type." Click "OK." Now draw your object. When it is completed, click on the blue arrow in the top left-hand corner of the workspace to return to the "stage." The object will now appear in the "Library" ready for use. Alternatively, you can import an existing vector image by selecting "File > Import > Import to Library."*

2 *Open the "Library" window (Window > Library), and drag the object onto the stage. This object will now occupy the first keyframe of Layer 1 (represented by a black dot inside the first frame in the timeline). Renaming the layer will save much confusion; in this example it has been titled "Blob." Add another keyframe further along the timeline (e.g. frame 30), by pressing F6 on the keyboard. Select the first keyframe (frame 1) again and right-click the mouse (Ctrl-Click on Mac) to bring up the context menu, and select "Create Motion Tween." The object is now ready for tweening. A background image has also been added using the same method described in step 1, with a new layer, titled "Background," created to accommodate it.*

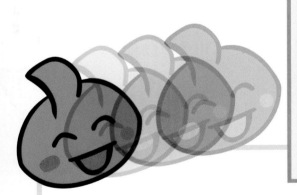

Color tween

Following the same principles of motion tween, Flash automates the process of changing an object's color in a gradual manner. In addition to this, you can tween the opacity (transparency) of an object, as well as its brightness and color overlay.

3 *Make sure that the object layer is selected, and click on the "Add Motion Guide" button found at the bottom of the timeline (second from left). An additional layer will be created above it (in this case named "Guide: Blob"). Now select the Pencil tool and draw an arc as shown in the screenshot; this will act as the path on which the tweened object will travel. If done correctly, the object should automatically snap to the path.*

4 *Click on the end keyframe, created in step two, and move the object to its finishing position on the path. Make sure that the center point of the object (represented by a small + sign) is aligned to the path or the tween will not follow it. Press the Enter/return key to see the result.*

5 *A simple path-guided motion tween has been created. To adjust the speed of the animation, simply shorten or lengthen the gap between the two keyframes. The closer together they are, the faster the action, and vice versa.*

Shape tween

To tween from one shape to another, create a second Symbol and place it in the final keyframe, then use the same steps described previously for the Motion Tween. Used in conjunction with the "Shape Hinting" function (where you direct the way the tweening process is handled), the Shape Tween tool can be very useful. It can also be applied to brush strokes and typography.

■ **The term "onion skinning"** is derived from traditional hand-drawn animation, where semi-transparent "onion skin" paper is used to trace the movement of objects from frame to frame. Without onion skinning, it is virtually impossible to animate anything smoothly or consistently. The logic is simple: if you are able to observe the adjacent frames, you can better decide how to draw or change an image in the sequence. In hand-drawn animation this is achieved by using a light box and a pile of animation paper or cels (transparent acetate).

Onion Skinning

■ **Why onion skinning is essential**
■ **Digital onion skinning**
■ **Checking that movements will work**

Digital onion skinning

In paperless animation programs, like Flash and Toon Boom Studio, the software emulates this effect by making frames semi-transparent and projecting them on top of each other. Duplicating frames and amending them with the onion-skinning feature can reduce the amount of drawing that is required by the animator.

If you have used the automatic in-betweening in these programs, the onion-skinning feature will let you check all the frames for consistency of movement. A similar effect can be achieved in Photoshop by using layers and adjusting the opacity. This is particularly handy if you intend to use Photoshop to ink and color hand-drawn frames that have been scanned.

◄ **Check that movement is smooth and natural** *In this example, you can see how only the arm of the character moves. Using vector animation software, like Flash, the original image can be duplicated and, using onion skinning, the arm can be adjusted to create the movement without having to redraw the whole character.*

How many frames?

You need to see only one or two previous images while you are working on a frame. Any more than that will end up causing confusion rather than helping. Only if you were editing a multi-frame sequence would it be necessary to show more.

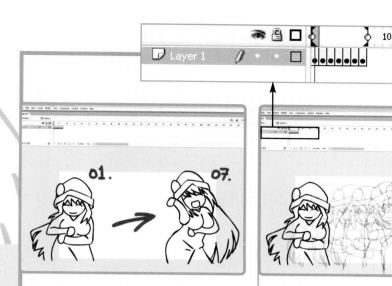

Remember to alter the number of frames you check according to the complexity of the movement you are creating. Sometimes you will need to see only three or four frames, but other times you may want to see the entire sequence.

1 *The first and last (key)frames of a short, seven-frame animated sequence of a girl dancing and shuffling from left to right.*

2 *When Onion Skin is toggled on in Flash, you will see the adjacent frames as if looking at a stack of animation cels on a light box. In this instance all seven frames in this sequence are visible.*

Working with digital onion skins

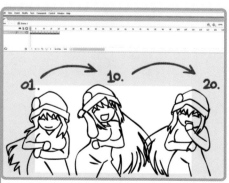

3 *The number of viewable frames has been reduced to four at a time, including the current frame. When the preview is played, the fadeout gives the image a "trail" effect.*

4 *The animation has been extended to 20 frames and shows the three keyframes for this sequence.*

5 *Showing all the frames in this 20-shot sequence makes it almost impossible to ascertain what is happening from one frame to the next, although it does give a good sense of movement. The top frame has been colored to make it stand out.*

▣ **Movement is the key** feature that distinguishes anime from manga. The genre of anime you are intending to create will dictate the range of character movements you will have to produce. A typical romantic shojo anime may only require you to animate a ponderous stroll here and some flowing hair there, while an action-based anime will be a lot more demanding. Complex fight sequences, special effects, and elaborate movements are staples of that genre, and can present a challenge for novice and amateur animators. Without the budgets or experience of a professional anime production team, the lone home animator will have to learn how to economize his or her output, and choose projects that are suitable in scope.

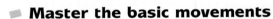

62 BASIC MOVEMENTS

Be realistic about your abilities and the time you have to dedicate to a project before you begin it. Try to steer clear of anything too ambitious for your debut piece, avoiding concepts that will require a lot of action sequences. Instead stick to genres such as comedy or romance, which can be conveyed succinctly with a minimal amount of onscreen action. Prepare yourself by learning some of the basic and most commonly used movements, like full body turns, sitting down, walking, head turning/tilting, and hand gestures.

These actions may seem modest, but collectively they go a long way to covering many everyday movements—and, bearing in mind that each action can be viewed from various angles (each with a unique animated sequence), you begin to see the enormity of the task in hand.

▣ **Master the basic movements**
▣ **Anime-specific movements**

Animator's tip: Shortcuts

Before you start animating, a useful exercise is to sit down, watch some anime, and closely observe how the animation is done, paying special attention to character movements and framing.

You will probably notice the clever ways in which animators take shortcuts to reduce the need to animate full body movements, thereby saving time. Tricks like shrewdly choosing camera angles so that certain parts of the body are cropped off the screen (e.g., an extreme closeup), or cutting the sequence in such a way that the entire length of the movement isn't needed for the sense of the action to be conveyed (e.g. changing the camera angle halfway through an action). Studying and utilizing these techniques will help you speed up your output.

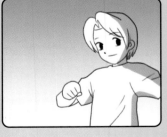

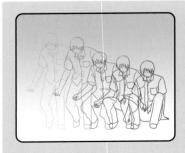

Perspective

Perspective is an important consideration when you are animating a figure moving toward or away from the camera. It is not easy to recognize how disproportionate the apparent dstance traveled is, as something approaches or recedes. If we suppose that the character is coming towards the camera at an even speed, over a notional 66 frames (or nearly 3 seconds) the half-way point, drawing no.17, is shown here. By drawing diagonals, as illustrated, from the first and last positions, the mid-point is established by the intersection of the diagonals.

33

17

1

Common anime actions

Below, and over the next few pages, is a repertoire of movements to help you to start making animated sequences. Use them as a rough guideline; don't be afraid to deviate from them. A mixture of common, everyday actions and anime-specific ones are included for your reference.

Head turn/tilt

There are a lot of hidden intricacies to animating head movements that cannot be overlooked. The most important of these is retaining the consistency of the head shape while turning or tilting it, because any deviations will make the character's head appear to be fluctuating in shape and size. When animating a head turn, pay special attention to the line that represents the cheek. Notice how it subtly changes shape.

When the head tilts, ensure it stays the same size throughout and only the facial features change. Also pay attention to the position of the eyes in relation to the ears.

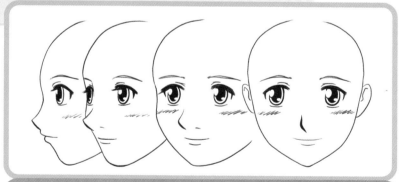

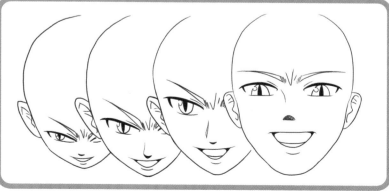

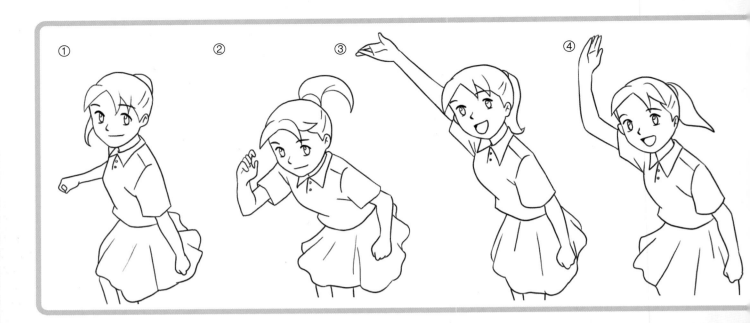

① ② ③ ④

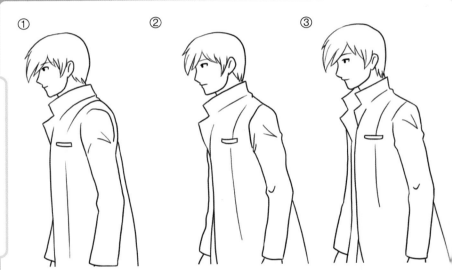

① ② ③

► Body turn

This action can be used in either direction, from profile to frontal or frontal to profile. It is worth spending time practicing and working with this action, as it will be used a lot.

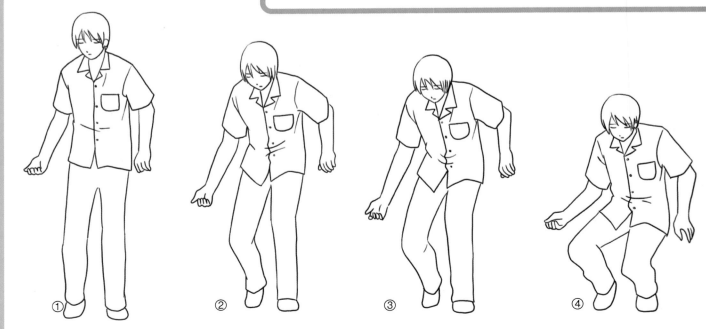

① ② ③ ④

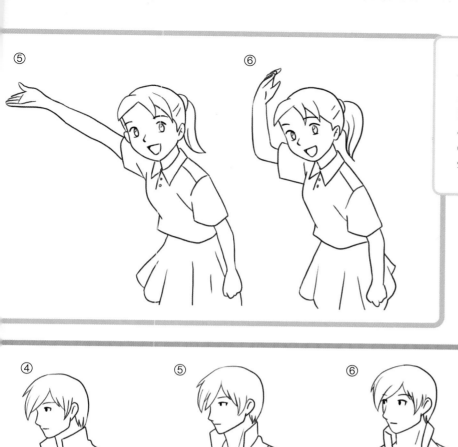

⑤ ⑥

The waving action in this example is suited to a young character as it is very expressive and childlike. An adult character would have a less expressive arm movement, and a straighter posture.

▼ *The only way to animate movements correctly is to look at the shapes people make when they are moving. Observe people around you, look in a mirror, ask your friends to let you film them so you can replay sequences and check your art against them, or use a poseable mannequin like this one.*

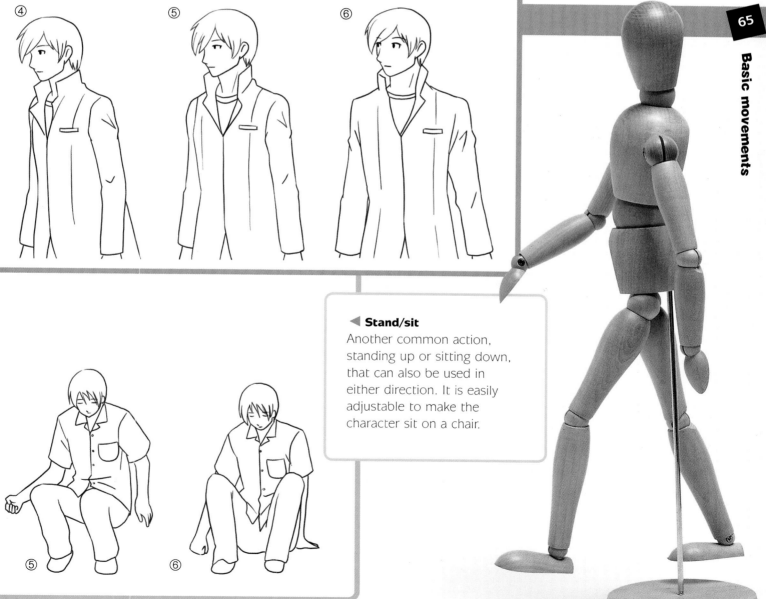

④ ⑤ ⑥

◀ **Stand/sit**
Another common action, standing up or sitting down, that can also be used in either direction. It is easily adjustable to make the character sit on a chair.

⑤ ⑥

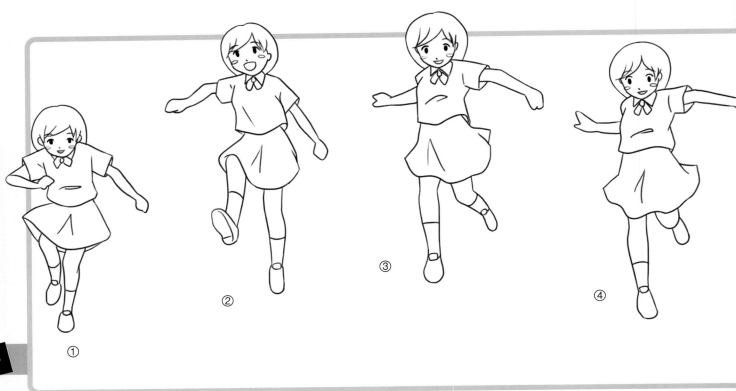

① ② ③ ④

▼ Bow

Bowing is standard etiquette in Japanese culture, and it signifies being humble, or showing respect. If you are planning to create an anime based in Japan, this is an essential action to implement to help your piece look more authentic.

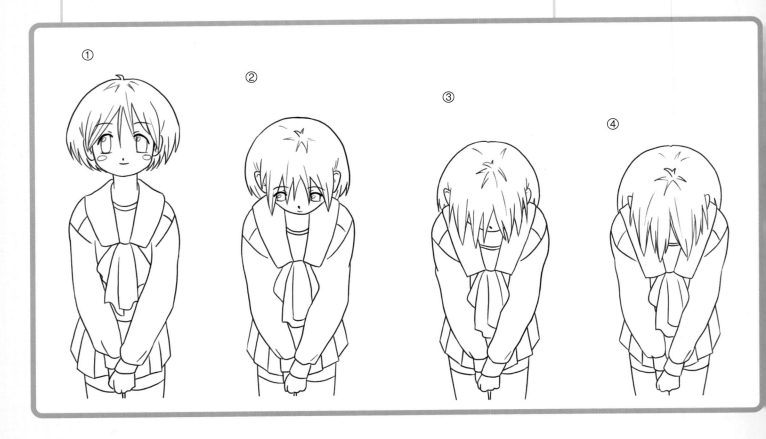

① ② ③ ④

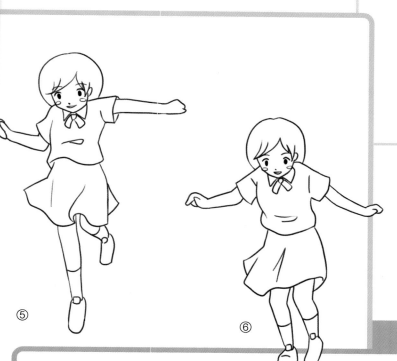

⑤

⑥

◀ Jump/leap

This action is appropriate for a small-set character. It is more of a forward leap into the camera than a vertical jump. A vertical jump would consist of a lower initial crouching position with the legs parallel to each other, except when airborne.

▼ Bragging

This is a typically "anime" gesture, commonly used to convey a character's arrogance. The facial expression conveys superiority.

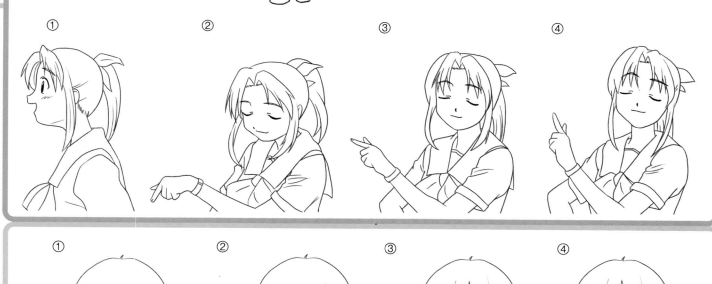

① ② ③ ④

① ② ③ ④

▲ Shock

In this sequence, body language and a subtly altering facial expression convey the character's shock and surprise.

There are two facts about the walk cycle that you will discover when you start animating: how frequently it is used, and how difficult it is to get right. A walk cycle is defined by four key stages, known as contact, recoil, passing, and high point. By studying these closely, you will begin to appreciate the mechanics of how the legs interact with the ground and how the whole body is involved. Understanding the dynamics of this seemingly simple action will enable you to animate a natural-looking walk cycle.

▶ **Expressing personality** *You can express personality through a character's walk. The teenager slouches, while the young girl bounces.*

68 THE WALK CYCLE

- **Mastering the walk**
- **Considering frames**

▼ *The four stages of the walk cycle—contact, recoil, passing, and high point—have been exaggerated in this example so that the differences are more discernible.*

Key stages

Contact
The contact point is the moment in the walk cycle where the character shifts his weight from one leg to the other. The contact pose is the meridian or middle of the walk cycle and occurs three times: once at the start of the cycle, once halfway (which mirrors the first), and once at the end (which is a repeat of the first). If the right foot is extended forward, the hips should be rotated so that they point down to the right and are jutting slightly forward. The shoulders should be rotated in the opposite direction of the hips so that the character remains balanced. The arms should always be in the opposite direction of the legs. If the right leg is extended forward, the right arm should be rotated backward. Everything is then reversed when it is the left leg that is being extended.

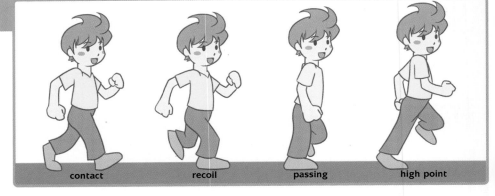

contact · recoil · passing · high point

Recoil
This comes directly after the contact pose. Here, the foot that just contacted is on the ground, with the back heel lifted and the knee bent. The hips should move down toward the ground slightly. This is the lowest point in the walk cycle.

Passing
In this position the foot touching the ground should remain flat. The foot that is off the ground should be lifted slightly, and about to swing forward to overtake the other leg.

High point
As the name suggests, this is the highest point in the walk cycle. The weight of your character should be shifted up and lunging forward. This pose is basically preparing your character to "fall" into the next contact pose (a mirror of the first).

Taking the four key stages, the rest of the sequence can be mapped out to create a full walk cycle. The next four frames of the cycle are simply the mirror opposites of the first four positions (in this instance the character's left leg is grounded in the fifth stage). By the ninth stage the cycle loops back to the beginning and one complete cycle is achieved. This loop can be repeated over and over to create one long walking sequence.

The full cycle

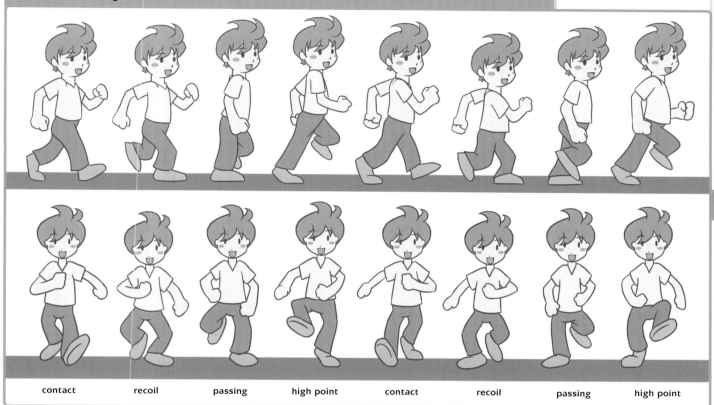

| contact | recoil | passing | high point | contact | recoil | passing | high point |

Frame rates

The frame rate at which you animate your walk cycle will depend on your intended output. To save some time when animating, work at half the desired frame rate; in traditional animation, this is called "animating on twos." For example, if you wanted to output at 24 frames per second (fps) (the standard frame rate of most commercial film) you would animate at 12 fps. So, if you were to animate the average walk cycle (one second in length) "on twos," you would end up with 12 frames of completed animation. Here is a rough idea for the timing of the key stages of a cycle animated at 12 fps:

Frame 1: Contact
Frame 2: Recoil
Frame 3: Recoil
Frame 4: Passing
Frame 5: High point
Frame 6: High point
Frame 7: Contact
(mirror of frame 1)
Frame 8: Recoil
(mirror of frame 2)
Frame 9: Recoil
(mirror of frame 3)
Frame 10: Passing
(mirror of frame 4)
Frame 11: High point
(mirror of frame 5)
Frame 12: High point
(mirror of frame 6)
Frame 13: Contact
(copy of frame 1)
Frame 14: Recoil
(copy of frame 2), and so on.

Timing

Information about your character can be expressed through the length of time it takes for a walk cycle to be completed. The average walk cycle is about one second long. A longer walk cycle will imply that the character is larger and more lumbering, while a shorter cycle, logically, has the reverse effect. A small character may do two complete cycles in the time a big character completes one, while traveling at the same pace.

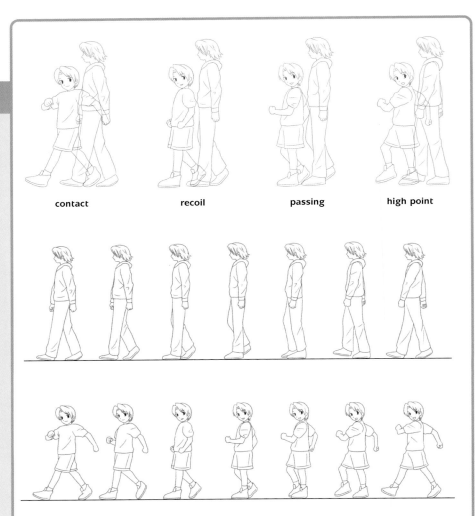

contact recoil passing high point

▲ **Child's walk cycle** *Here, both the leg and arm actions are pronounced and exaggerated to give the impression of childhood vitality. The adult's, on the other hand, has a more subdued movement and pace.*

Different strokes

The way we walk can reveal a lot about us, and each of us has a uniquely individual stride. The use of a specific walk cycle can be very effective to demonstrate the mood and personality of a character, and should not be overlooked. We have already established that the timing of the cycle can determine the weight and heft of a character, but the customization doesn't end there. For example, a little girl full of vigor and vitality should walk with her head up and chest out, with an urgent march as if she can't wait to get to where she's going; a moody teenager, on the other hand, may slump forward, shoulders hunched, head down, strolling along apathetically. A simple deviation from the standard walk cycle can very vividly define a character's personality trait. Always consider each individual's walking style before animating.

Walk the walk

After completing the walk cycle animation, it is time to learn the different ways in which it can be applied on screen. There are two common approaches to this:

Static background

Here, the background is kept static while the character is shifted from right to left (and paced accordingly) to generate a sense of traveling. The static background method is usually associated with characters walking toward or away from the camera, and wide views of characters traversing grand landscapes. In terms of side-view/profile walk cycles, it is more common to use the parallax scrolling method.

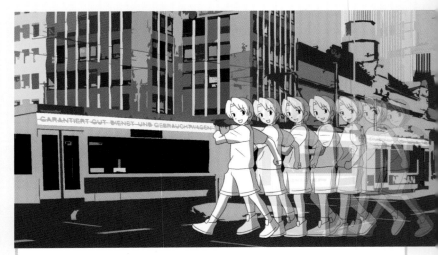

▲ *The walk cycle against a "static" background, where the character moves across the frame. In this example, it would make a very short sequence.*

The run cycle is similar to the walk cycle, except that fewer frames are needed to animate a complete cycle. This is because an average run cycle is a lot quicker than the walk cycle, resulting in less output frames. In fact, by just creating the four key stages and mirroring them to generate the next four (as outlined opposite) you can produce a sufficiently complete run cycle. The only other thing to bear in mind when animating a run cycle is that it is only during the "passing" key stage that the character ever touches the ground; for the rest of the sequence the character is in the air.

Animator's tip: Limit walk cycles

As always, it is very helpful to study some professional anime productions before beginning your work. What may strike you is how rarely the full walk cycle is shown. Animators will often concentrate the camera on the upper body (or even just the face) in order to relieve them from having to animate the complex leg movements every time a character walks. This is a very effective timesaving technique that can also help make the overall composition of the piece more varied and interesting.

Run cycle

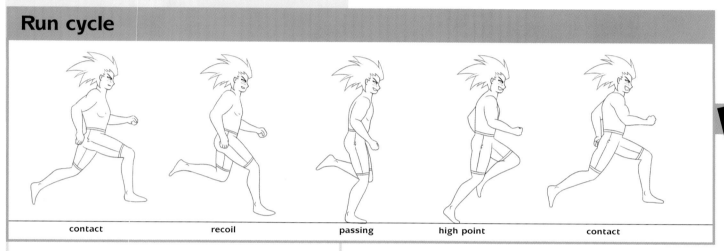

contact recoil passing high point contact

▲ The run cycle requires fewer drawings to make up a complete cycle. Notice how the character rarely makes contact with the ground.

Further reading

Eadweard Muybridge's photographic studies, *The Human Figure in Motion* and *Animals in Motion*, are excellent reference resources for any animator.

Parallax scrolling

Parallax scrolling involves using a background image that moves at a slower pace than the foreground action to create an illusion of depth and motion. Instead of moving the character from right to left, it is kept static and the background is moved from left to right to give the illusion of the character traveling. Adding background layers creates a greater sense of depth (the further back the layer, the slower it moves). Using animation software with a multiplane camera makes this much easier. Parallax scrolling is great for scenes with lots of dialogue because it can be looped indefinitely. Making the characters chat while walking toward their next destination lets you jump seamlessly from one scene to another.

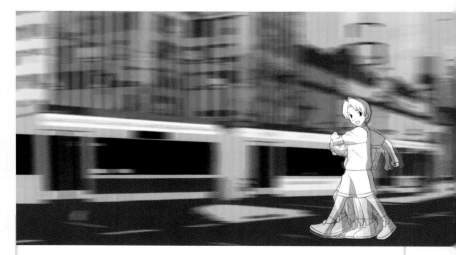

▲ The parallax scrolling method moves the background while the walk cycle is animated in a fixed spot in the frame. This is akin to using either a following pan or a tracking shot in filmmaking.

■ The effective use of exaggerated facial expressions is crucial to achieving the larger-than-life characters for which anime is renowned. It may seem like a complicated area, but facial animation is, for the most part, relatively easy. Most facial expressions are communicated by a set of simple eye/eyebrow and mouth movements, so mimicking them in animation is not all that difficult once you have a grasp of the basics.

■ Use expressions to describe personality

■ Start by mastering basic expressions

72 FACIAL ANIMATION

Facial expression as character differentiators

All successful anime shows have at least one thing in common: a strong cast of expressive characters. Stories are about people and their situations. As with other forms of fiction, it is impossible to make a story come alive without interesting characters doing interesting things, and it is no different in anime.

The face is the most expressive part of the human body, capable of succinctly communicating a huge range of emotions and feelings. As individuals, we all have a unique range of facial expressions that makes us special, and your fictitious creations should be no different. By assigning an appropriate assortment of expressions to each character you can really build up their persona and help make them instantly recognizable to the audience.

Basic expressions

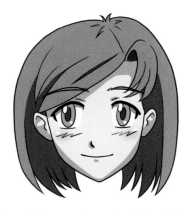

Normal/happy *A standard cheerful expression, with no signs of exaggeration.*

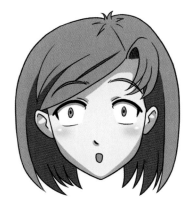

Shock *A good expression to use to articulate a character's sense of shock. Notice the extra-small pupils that contribute to this effect, and the slightly slack jaw.*

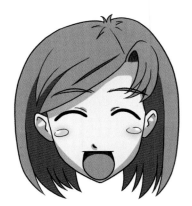

Overjoyed *A pronounced version of the happy face. This is conveyed by tightly closed eyes and a wide-open smile. This is a very popular expression that is used liberally in anime, and it is synonymous with young/cute characters.*

◄ Effective use of facial expressions
To fully emphasize a particular facial expression, use an extreme closeup face shot. This will also enable you to articulate the expression with a greater level of detail than a standard shot would allow.

► Express your characters' personalities Here are three characters displaying very different expressions. Notice how their faces alone contribute to their individuality, and hint at their possible character traits. From left to right: a determined-looking, slightly devious young boy; a serene young woman; and a man carrying a certain degree of sorrow.

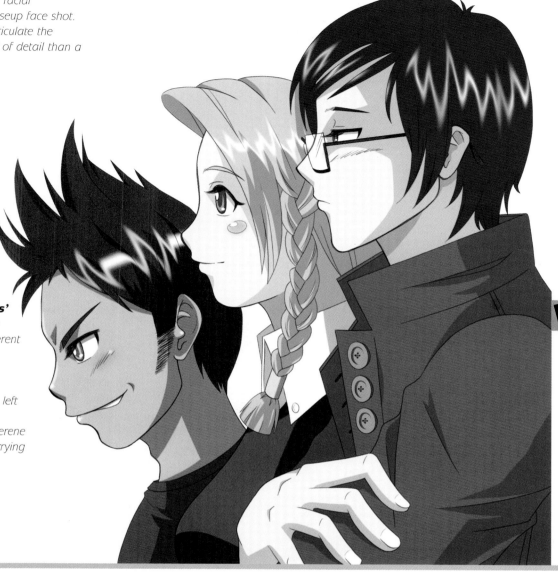

Anger The positioning of the eyebrows are important to this expression—notice the extreme angle at which they have been pitched, and the skin wrinkling in between.

Sad This one is all in the eyebrows. These communicate discontentment and sadness, as does the downturned mouth.

Bored/tired Use this to convey a character growing uninterested or feeling physically drained.

Stock anime expressions

Compiled here is a selection of useful character-defining facial expressions—some with hand gestures— embracing a range of diverse characteristics for your reference. These are classic expressions, which you may want to use to begin with. After a time, you'll want to make your own choices and develop your own repertoire of character expressions.

▼ **Brash and mischievous**
This expression fits a youthful character with a brash and confident nature. The wry smile and wink suggest a playful, mischievous temperament and a certain immature charm that is often found in shonen *protagonists.*

▲ **Longing gaze**
The kind of expression regularly found in romantic anime, commonly exhibited by introverted, sorrowful characters.

Animator's tip: Animating faces

When drawing figures on a computer, some animators recommend keeping the facial expression as a separate layer. Basically, you draw a figure with a blank face. Draw the features on a separate layer. This way you can insert a new expression layer without redrawing the entire figure.

◀ Reluctant tears

This expression can only be exploited at certain dramatic moments of the plot, but nevertheless it is useful to have this in your vocabulary of expressions. Notice how the character's eyes look toward one side (as though avoiding eye contact) and how she's clutching her hands (a physical metaphor for clasping her heart). Details like these are essential to conveying the emotion comprehensively.

▼ Who cares?

This blasé, uncaring look requires a laid-back, "who cares" kind of appearance, and a sense of composure that exudes confidence and attitude.

▶ Slower than average

An apt expression for depicting a character's dimwittedness. The big puppy-dog eyes suggest innocence and gullibility; the slack jaw hints at confusion. This is a good expression to use for empty-headed halfwits (like Osaka from Azumaga Diaoh!)

Lighting is sometimes dismissed as an afterthought by first-time animators, but this is a mistake. Proper use of lighting not only boosts the visual appeal of your output, but is also very effective in creating a sense of atmosphere. Lighting need not be entirely realistic in every scenario. Abstract, expressive, or emotive use of light can help communicate the mood and atmosphere of each scene very effectively.

Understanding light sources

Using light to create atmosphere

Lighting Effects

Unfortunately, unless you plan to animate in 3D CGI, there is no simple or automated way to apply lighting. Creating coherent and striking lighting effects in 2D animation requires forward planning, together with a good knowledge of light sources and shadow-casting. To begin with, it is essential that you understand the basic light source positions.

The series of images shown here demonstrate a range of common light source compositions: from in front; from the left; from the right; and from behind. The outline of the character remains the same throughout, and the light source is alluded to by the arrangement of shadow tones. In these examples, only two tonal layers are used. This is a common practice in anime, since the more tonal layers you use, the more work it involves. Two tones will suffice in most situations (see Cel shading on page 18). By the appropriate arrangement of shadow tones, you can simulate lighting effects from a variety of angles. Essentially, you are trying to make a 2D image appear three-dimensional; how successfully this is achieved comes down to how accurately the tones represent the contrast between light and shadow. The key to emulating believable lighting is in the use of dark shadow tones to effectively emphasize the character's or object's contours.

From the front
This is used as the default lighting option, when no specific set-up has been chosen. The light falls squarely on the face, and shadows are formed only around the edges and on the neck, under the chin. This is easy to create and it shows the character in its simplest form.

▶ **Elaborate lighting** *Compare these two identical character illustrations. Notice how the application of some basic lighting effects (lens flare, background shadow, and graduation) can transform the atmosphere, and give the image added depth. In anime, such elaborate lighting effects are not always practical, but this shows lighting's potential.*

From behind

Known as backlighting, this is less frequently used than front lighting but is striking in its effect. Use this type of lighting when the character has its back to the main light source. To give extra emphasis, the edge of the character can be graduated slightly— as in the example—to give it the effect of over-exposure, as would happen when using a camera.

From the sides

Here, the shadows become a little more complex. Half the face is in light while the other is in shade. The nose acts as a border between the tones, with the facial features (the nose, eye sockets, and chin) accentuated by the contrast. This kind of lighting is not used too often in anime, as it takes a lot of pre-planning in every scene.

Colored light

An example of how colored light affects the subject. Its use depends on the scene's overall ambient lighting, and the two should always match to avoid inconsistencies. Most computer software programs have their own Color Overlay effect built in, so this shouldn't be a problem.

Environmental lighting

Use lighting effects to create atmosphere. Here, the same characters are placed in three different settings, each with its own distinct, environment-specific lighting effects applied.

▲ **Sunny day** *The characters are bathed in bright sunlight. The scene is evenly lit and displays vivid colors. A lens-flare effect has been added to emphasize the brightness.*

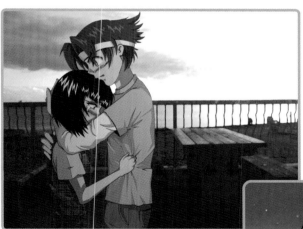

▲ **Dusk** *The scene is saturated by a wash of orange sunlight. The characters have been given a slight orange overlay to match the color of the light and the backdrop. It is important to match the characters' color with that of the ambient light (without exaggerating), or else they will not look like part of the scene.*

◀ **Night falls** *The characters are reduced to silhouettes, with only the moonlight accentuating their forms. Silhouettes can be visually arresting and, when used appropriately, help create dramatic scenarios.*

■ **The effective use of audio** can boost the overall fidelity of your work. Sound can add or subtract from the cohesiveness of the visuals, and when the two work in harmony, the results are fantastic. Take the horror genre as a case in point; haunting music and creepy ambient effects do not just help set the scene, but make it what it is, creating that oppressive, suffocating atmosphere.

Even though most solo anime artists will understandably prioritize the actual process of animating over auditory elements, the importance of sound and sound effects to a piece of work can not be underestimated. Most viewers take this for granted, but a closer study of any decent anime will reveal a myriad of audio elements layered within: voice acting; footsteps; birds chirping; cars passing by; environmental ambience; crowd noises. All these elements come together and contribute to the overall soundscape, creating a much more believable, living, breathing world.

78 SOUND AND SOUND EFFECTS

Recording sound

Like any other aspect of creating an animation, there's a lot of subtle artistry in sound effect manipulation, recording, and implementation. Those already into sound engineering and recording music have a marked advantage. For the uninitiated, here is a brief introduction:

1. Most PC soundcards have the ability to receive sound input from a microphone, via a standard ⅛-in. (3 mm) headphone jack. Although plugging directly into your PC will allow you to record, don't expect great results from this setup. It is advisable to either upgrade your soundcard (if you have an older machine with PCI slots), or acquire an audio interface (if you have a newer machine with USB2 or firewire ports). An audio interface will help to boost the signal strength and produce a noticeably superior sound sample. If you plan on doing a lot of sound recording in the future, look to spend US$150 or more on a quality interface.

2. To begin recording, you will need the relevant software. Since you'll only be recording sound effects, it isn't necessary to purchase expensive recording software such as Cubase or Logic. Consider Cool Edit or Goldwave for Windows-based PC, and Studio Vision or Unity for Apple Macs (all of which are either cheap or free). These programs are relatively simple to understand, and can easily be grasped by spending a little time experimenting with the software. You could also consult the help files (usually assigned to F1) for more specific information.

3. In an ideal world, every sound effect you require would be recorded from the actual source itself, but due to time constraints and other physical limitations it's not always possible to go out and record everything in this way. So don't be afraid to improvise and be inventive and create the sound you need—for example, rustling paper to replicate the sound of a crackling fire, or coconut shells for horse hoofs? Try dripping water into a bowl for rain. Even professional sound effects artists generate most of their sound effects from props in a studio; the only limitation is your own ingenuity and resourcefulness!

Acquiring pre-made sound effects samples

If you're working on a tight schedule and don't have the time to record your own sound effects, one option is to get hold of existing samples from an internet sound database or a samples CD. Spend some time searching on the internet and you'll soon come across websites offering samples—some free of charge—for a wide range of sounds. While those that require licensing fees are royalty-free and ready for commercial use, be careful with the free ones. Check the small print as to whether or not the source file is copyright- or royalty-free before using it in your work; otherwise, you may find yourself facing possible prosecution.

Useful links for effect samples

Flash Kit: **www.flashkit.com/soundfx**
Ljudo: **www.ljudo.com/default.asp**
Absolute Sound Effects Archive: **www.grsites.com/sounds**
A1 Free Sound Effects: **www.a1freesoundeffects.com**
The Free Site: **www.thefreesite.com/Free_Sounds**
Audiosparx (fee required): **www.audiosparx.com**

Let there be music

Music in native Japanese anime TV series follows a strict tried-and-tested formula. The flashy opening and ending sequences (known as OP/ED respectively) usually coincide with some popular J-pop or J-rock chart topper of the time, which then becomes the series theme music, while background music (known as BGM) is produced by an in-house team of musicians. These tracks cover a range of possible scenarios (such as action, comedy, romance, etc.), and are repeated throughout the series to give the show a sense of familiarity and consistency.

This format is actually not all that relevant to an amateur animator, since it only works with a long-running series (which requires a huge budget to sustain).

If you're planning on doing a one-time piece, it is more relevant to study the use of music in feature-length anime, where you can learn a lot about how music is used to create atmosphere and suspense.

Because music is such a subjective entity, there is no clear answer to what is and what isn't appropriate. Whatever music fits your artistic vision is ultimately the correct choice, but don't be afraid to take some chances. Remember that gruelling scene in Tarantino's *Reservoir Dogs* involving Mr. Blonde and the ear severing? He chose the cheerful sounds of "Stuck in the middle with you" as accompaniment to the on-screen violence, giving the scene a surreal edge that ensured its iconic status.

Paying fees for music

Unless you are a musician, you will have to acquire music from an external source. Again, the internet is a very good place to scour for content, but unlike sound effects, unfortunately, you will have a hard time finding free ones. If you are creating an animation for your own pleasure, it doesn't matter what music you use. But if you are thinking of getting your work published or distributed in any way, you will have to pay for royalty-free music, which is expensive.

Useful links for royalty-free music

The Free Site: **www.thefreesite.com/Free_Sounds**
Canary Music (fee required): **www.canarymusic.com**
Thebeatsuite (fee required): **www.beatsuite.com**
5 Alarm Music (fee required): **www.5alarmmusic.com**

Lip synching is the process of animating a character's speech to fit a pre-recorded voice track. This can be done either manually by noting the phonetics on a dope sheet and then drawing them, or with software that automatically analyzes the sound sample and translates it into phonetics. The voice actors' parts are generally recorded first, and sometimes they are even videotaped to aid the animators in creating their character's personality, or mimicking their particular accent. In anime lip synching, the tongue is rarely drawn while the character is speaking, and teeth are depicted as a row rather than drawn as distinct, individual teeth.

◀ **Conveying feelings**
Characters convey their feelings through voices as well as through body language.

80 LIP SYNCH

- **Interpretation of sound into phonetics**
- **Explanation of voice animation**

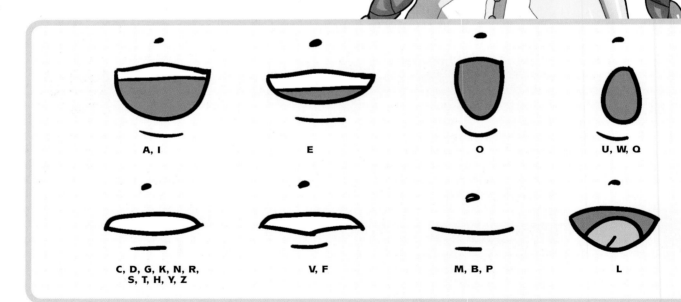

A, I　　　　E　　　　O　　　　U, W, Q

C, D, G, K, N, R, S, T, H, Y, Z　　　　V, F　　　　M, B, P　　　　L

▲ **Basic mouth movements**
Anime lip synch is different than western cartoon lip synch. There are eight basic visemes used to animate speech (a viseme is the shape used to animate talking). These visemes correspond to the phonetic spellings of words, not the literal spelling. There are four visemes for vowels, and five for consonants (one is used for both).

Lip synch in a lot of anime appears basic compared to western cartoons. This is partly because, compared to English, Japanese has fewer sounds that make up words, and because they animate speech with more subtlety. Anime puts more emphasis on the expression of the character while talking than on exaggerating the movements of the mouth.

Title				
PRETEND				
Action		Scene	5	Sequence 2
Sound of large creature running through undergrowth	Dialogue	W	●	4　3
		O	●	
Elvis's eyes are darting from side to side		I		

Effect of expressions

Consider the effect of the characters' expressions on the way that they talk. A happy character will have an open, expressive manner of speech, whereas a gloomier character will barely move or open his or her mouth. Even characters' personalities affect the way they talk: sarcastic or evil characters may talk out of the side of their mouth, while cute characters tend to have small, narrow mouths. Look at how other animators depict different emotions and personalities through speech.

Animator's tip: Speak the script

It can often help considerably to speak the words of the script to yourself while looking in a mirror. Speaking the words slowly can help you choose the correct facial expressions.

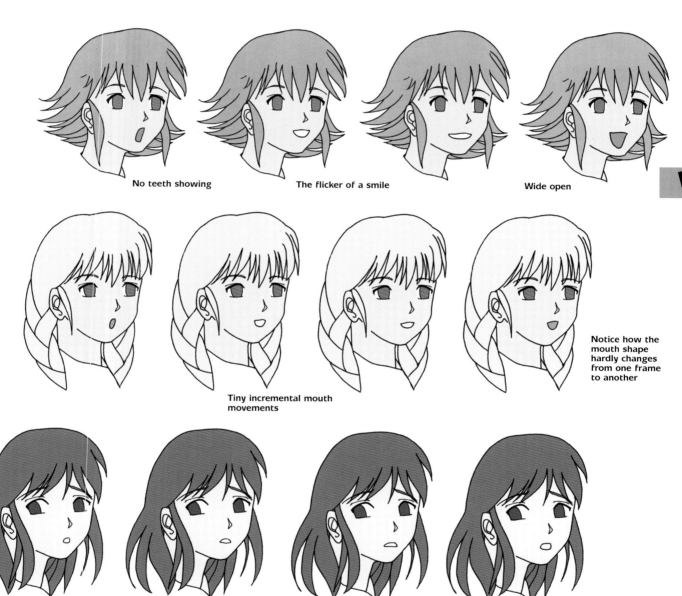

No teeth showing The flicker of a smile Wide open

Tiny incremental mouth movements

Notice how the mouth shape hardly changes from one frame to another

The eyes help to express sadness

The slightly downturned mouth conveys mood

◄ **Using an x-sheet**
Plan dialogue animation by plotting it on an x-sheet (exposure sheet). Use the sheet to see the word and mouth shape coming up in the animation. Even if you intend to do the whole animation on your own, an x-sheet is essential for synching sound.

▲ **Matching mouth shape to mood** *These sequences show characters saying "konnichi wa" ("hello") with different emotions. Compare their expressions and notice how these affect the shapes made by their mouths as they talk.*

Animator
ALEX
Sheet No.
3
Camera instruction
& FIELD
(15 F.C.)

Anime-Specific Skills

Once you have learned the basics of 2D animation, you will want to apply them to an anime-style piece. The following chapter will look at some of the aspects normally associated with anime and different ways of creating them. They are all simple techniques that are easy to apply, and will make your anime look a lot more genuine. How to get movement out of still images, working with speed lines, making the most of anime's trademark eyes, and creating super-deformed (chibi) characters are all covered over the coming pages.

Western animation rarely uses any form of shading, and viewers are usually quite happy to accept this (if they notice it at all), so the addition of a single extra tone to represent shadow is usually enough. Sometimes a second shadow tone is added, but this only complicates the coloring process and the benefits may not even be noticed. You have to decide how you want to represent the lighting. When coloring individual frames of your animation, place the shading on a layer of its own, which is the equivalent of giving it its own cel. You may only need to amend the shade layer to achieve movement.

Marking up for cel shading

Creating shadows and highlights

◀ **Using shades**
Specific moods can be achieved by using shades of the same color for the whole scene. Using the color on black gives it a luster that, in this case, looks like polished leather or rubber. Using white for the highlights accentuates the strength of the light source. This image is not what is usually considered anime, but is an interpretation.

84 CEL-SHADING TECHNIQUES

Creating cel-shaded images

Highlights use the same principles as shading, except with a paler color. In fact, simply using one shading color and one highlight is sufficient to give your character or prop a well-rounded sense of volume. Hard edges and corners of shiny objects, such as swords, often pick up sharply lit "glints." These are usually shown as white and star-shaped. For example, in setting up a sword fight, the shot may show the samurai in a still pose with just a glint on his sword. It may seem clichéd, but audiences expect it in order to show the tension and announce the inevitable demise of one of the combatants.

Vector-based illustration and animation software is ideally suited to creating cel-shaded images as they are designed to work with areas of flat colors. All the shaded areas remain editable and independent from the main color.

1 *First, pencil in the main elements.*

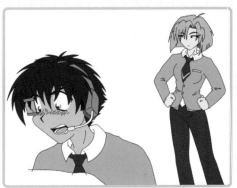

2 *Then ink over the pencil lines. Save this as one layer.*

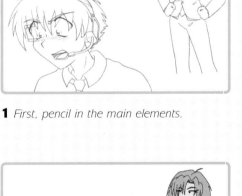

3 *Flood in the base colors, and save as a new layer.*

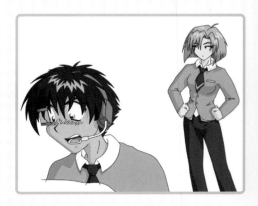

4 *Add in the shading on separate levels. Here, two layers have been added: one for the darker shadows and another for the highlights.*

Animator's tip: Cel shading

A common mistake with cel shading is to adopt too many steps, or to space shade levels too evenly. You really only need three shades to color an item: the actual color of the object itself, a darker tone for the shadow, and a paler one for the highlight. Varying the tonal intensity of the shadow and/or highlight will alter the apparent strength of the light source. Determining where to place the shading will often come down to practice and trial and error. Working digitally allows you to do this without wasting masses of paper and paint.

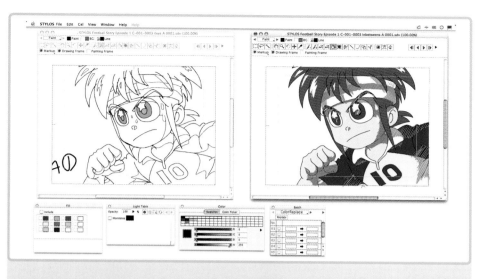

▲ **Markup** *The animator and/or in-betweener will mark up the areas that need cel shading. These will often be done with different color lines. This process is simplified with animation software, such as Stylos, which allocates the marked-up line work to a separate layer to facilitate the clean-up and digital painting. Because large areas of flat color are used, it can be done quickly with the paintbucket (fill) tool.*

Cel shading in 3D

There is an increasing number of CG films being made, the reasons for which are not all to do with popular trends. Although most CG animation has the shiny look we are all familiar with, it is possible to create cel-shaded 3D images that, if done properly, can look like 2D animation. Some of it is done so well and integrated so seamlessly with 2D that it is impossible to tell it was originated on computer. Studio Ghibli's movies since *Princess Mononoke* have achieved this with great success, but it has to be said that their 2D work is also at a very high level.

► **Caption** *for pic with comment on dramatic lighting effects Caption for pic with comment on dramatic lighting effects*

►► **Toon shading** *Haruwo is a character-driven anime that was originally created using Animation: Master, and rendered using a toon shader.* © ShaoGuee.Coma license programme of Ingram Co., Ltd.

Lighting

Each software program will have its own approach to lighting, so to achieve the optimum effect you will have to experiment to get the correct illumination for the mood of the shot, and the right balance of contrast between the shades. Render settings will take some experimentation, too. Spend plenty of time to get it looking how you want, rather than accepting something close. It may take some time to start with, but the perseverancewill pay off.

Toon rendering

The easiest way to get a cel-shaded 3D image is to use a program that includes toon rendering, or one that accepts toon-rendering plug-ins. Some packages, like Animation:Master, include cel shading as standard and are popular with anime creators. Some programs will export animations as vector Flash files, which can give an excellent simulation of cel shading, as well as creating a file that can be imported into a 2D vector animation program like Toon Boom Studio.

■ **If the idea of** rendering anime backgrounds is daunting, rest assured that you are not alone. Almost every budding anime artist starts out by concentrating on character design, as it is undeniably the most exciting aspect of creating your own intellectual property. However, there are two simple methods for creating strong background art. Start with these methods, and backgrounds will no longer be something to worry about, and in time you will develop your own favorite methods.

■ **Exploring photo manipulation**
■ **Simple digital painting techniques**

1 *Obtain a photograph of the desired background by either snapping it yourself or getting permission to use an existing photograph (never use photos to which you do not explicitly have the rights). Open it up in Photoshop.*

86 RENDERING BACKGROUNDS

Digital painting

Advanced imaging software such as Photoshop is great for many aspects of creating anime, but when it comes to creating backdrops, Corel Painter reigns supreme. Painter is a very unique program, in that its sole purpose is to emulate as accurately as possible the act of applying paint to paper/canvas. Painter obsessively apes reality, so every tool within is imbued with a palpable physical presence; paint mixes together when strokes cross over, palette knives realistically smear and smudge thick paint, brushes dry up as long strokes are made, and so on. Painter is a great tool for achieving the hand-painted look of anime backgrounds, with the flexibility of digital imaging.

1 *Start by creating a rough sketch of the background. Use a photo for reference, since it is very difficult to create a scene without some kind of inspiration or visual stimulus. Pay special attention to perspectives and keep everything aligned with the vanishing point.*

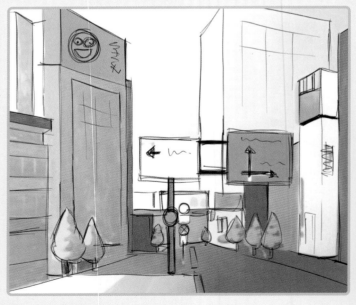

2 *Create a new layer underneath the sketch and begin applying color. By keeping the sketch on top, it is easier for you to keep track of the overview, making it much faster to get the base color down. At this stage, don't worry too much about neatness, just make sure that color is used consistently.*

Photo manipulation

By simply manipulating a digital photo or a scan, you can achieve great anime backdrops in no time at all. All it takes are some basic Photoshop skills.

2 *Begin by adjusting some of the photograph's parameters. Heighten the contrast a little to highlight tonal definition (Image > Adjustments > Brightness/Contrast), and add a touch more color saturation (Image > Adjustments > Hue/Saturation) for vibrancy.*

3 *Once you're happy with the adjustments, it is time to apply some special filters. While there is a whole suite of filters in Photoshop that can be utilized to achieve all kinds of different visual effects, the most suitable one for this task is Paint Daubs (Filters > Artistic > Paint Daubs). Do not be afraid to play around with the settings, as any adjustments you make can easily be undone. This filter will give the photo an instant watercolor-wash effect and soften unwanted details. Do not hesitate to try out other filters; you may come across something else that suits your vision more than the one suggested in this example. Remember, experimentation is the best way to learn.*

3 *When you are happy with the base colors, delete the initial sketch layer. It is now time to scrutinize the finer details. Make sure you fix the vertical and horizontal edges of buildings by making them as straight as possible. After touching up the image, begin applying some lighting effects (if applicable). Good lighting can really boost the atmosphere of a scene.*

4 *To finish, add final cosmetic details. Cityscapes such as the one in this example look more realistic when signs and billboards are incorporated into the scene, creating an urban metropolitan look.*

Anime's esthetic philosophy is markedly different from that of western animation in that it generally sacrifices high frame counts in favor of a greater level of detail per frame. By using minimal actual animation (with the use of still images), production time and costs are reduced, but not at the expense of detailed artwork. With shrewd planning and careful camera work, the story can still be conveyed as effectively as in any high-budget production, without sacrificing too much detail.

- **When to use stills**
- **Mixing stills and live shots**

Pre-production considerations

As an amateur animator you will want to make full use of still images, as you will inevitably be low on resources and time. It is important that you come to grips with this concept early on and consider avoiding the use of actual animation for whole scenes. Before production, you should formulate your ideas as a series of still manga panels and transfer them onto a storyboard (see Storyboards, page 34). Once the storyboard has been completed, look at each scene individually and decide whether actual animation will improve the overall outcome. If it really is needed, consider how you can economize on the drawing.

Take some time to contemplate what you consider to be the key moments of your movie and make a note of them. These will be the so-called "money shots," which can be lavishly created with extra attention to detail to really make them stand out. This could be in the form of a higher frame-count animation, a more elaborate sequence, or the use of dramatic cinematography. It is wise to limit these instances because of the extra work involved unless time is not an issue.

In fact, there are many situations where the use of still images will have advantages over typical frame-by-frame animation. Still images have a subdued, poignant quality that can be exploited to create tension and give the scene a certain amount of *gravitas* that would otherwise be hard to express.

Using stills effectively
An example of a still shot that adds to the atmosphere, rather than detracting from it. The couple is having an emotionally charged moment, and the static pose heightens the tension of the scene. No amount of intricate animation will convey this more efficiently. The effectiveness of the scene is also helped by the well-considered composition of the onscreen elements, while the detail in the artwork would not have otherwise been feasible.

The camera moves slowly upward to reveal the female protagonist's full expression. The use of still images does not mean total motionlessness; a simple camera movement can breathe life into a static frame.

The Ken Burns effect

By creating a still image much larger than the screen output size, you can freely move the camera around it. This method is very commonly employed in anime, and can be exploited to good effect, especially when more than one layer is used and incorporated with parallax scrolling. This technique is also known as the Ken Burns effect, named after the award-winning documentary maker who used it to create films from historical photographs.

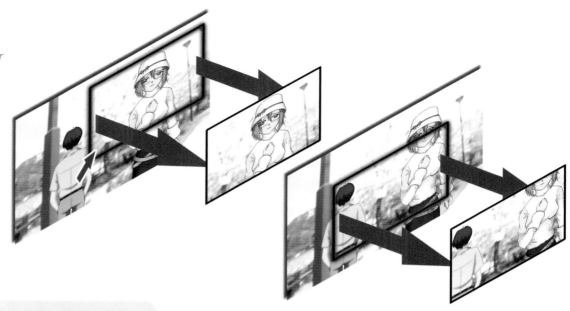

Using partially still close-up shots is an evolution from using totally still images, but with the same intent of creating a heightened mood. Close-up face shots are popular in anime, especially to accentuate a character's emotions.

Partially still close-up shots

▼ **2** *Because only the hair will need to be animated, create a new layer and add the hair outline, giving it 5 to 6 frames of animation. Each frame should have slightly different hair positioning, so that when the frames are looped, the hair looks as though it is moving.*

▶ **1** *Start by outlining the head and face only, as if the character is bald. The tighter the frame, the more dramatic the feel; here we've opted for a close face shot.*

◀ **3** *After coloring and the addition of a background, the image looks like this: a classic anime composition!*

Utilizing speed lines to depict a sense of pace is widely done in all kinds of line-based cartoon illustrations, regardless of origin or genre. This visual trickery is prevalent in manga, and its artists have perfected the use of speed lines to communicate a whole range of movements—much of which translates well to anime.

Although neither as crucial nor as widely used as they are in manga, speed lines are an important element in anime. They are mainly applied in action-oriented series, where the main purpose is to accentuate an already exaggerated sense of speed. Fighting sequences, where limbs flail about so fast that they disappear into mere lines, also utilize the technique. Speed lines are also found in comedy anime, where animators tend to exaggerate the onscreen action for slapstick effect.

90 SPEED LINES

- **When to use speed lines**
- **Using speed and blur**

Speed blurs

Speed blurring is a relatively modern addition to the anime world, brought about by the advent of digital animation and various high-end imaging programs. Without computers, the closest animators can get to a blurring effect is by using an airbrush or smudging. Programs like Photoshop are equipped with very sophisticated motion-blurring filters, which, when used with Flash or After Effects, can make speed blurring a much less daunting task. Although both speed lines and speed blurs are used to achieve similar effects, their application is very different. Speed lines are often used as backdrops to emphasize and dramatize speed, whereas speed blurs are actually applied onto the character itself to stress limb movements.

1 *In this example, the speed lines are applied to a profile shot of a character running, and are shown as straight horizontal lines. Two layers of speed lines are used: one as the background, and another, optional, one in front of the character (with sparser lines so as to not obscure the figure). Keep the speed lines animated to avoid a static feel.*

2 *By adding a motion blur to the character, you can further emphasize the speed. In this case, make sure the arm and fist component is placed on a separate layer from the head and body. Apply a strong motion blur to the hand and a weaker one to the head. This will help distinguish the different speeds at which the two components are moving.*

It's worth noting that this type of close-up camera composition (with speed lines) is very common in anime because it succinctly depicts the motion of running without the need for laborious run-cycle animations.

Creating impact

Speed lines are also frequently used to signify impact. In this example, notice how the point at which the speed lines converge represents the point of impact. This method creates a much stronger sense of contact, and is useful for fight sequences. Bear in mind that this effect should only be used for critical moments, like a finishing blow, because overuse will reduce its impact.

Running toward the camera

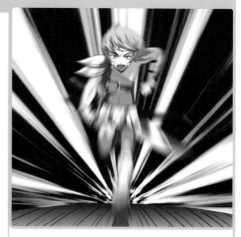

1 Here is a hero-type character running toward the camera. No speed lines or speed blurs have been added, and the animation looks perfunctory.

2 Dramatic speed lines have been added to the background, giving the overall scene a heightened sense of urgency and pace (notice that speed lines have also been applied to the ground). When applying speed lines like this, always animate them slightly, otherwise they will end up looking flat and static. Do this by creating three or four different frames of speed lines and looping them in a sequence.

3 A simple motion blur has been applied to further exaggerate the sense of speed. This is achieved with Photoshop, by adding "Radial Blur" to all the frames of the character's animation before embedding them into the sequence.

Using manga as reference

Speed lines are used extensively in manga, which makes them a rich source of reference should you need to learn more techniques for applying them. These examples clearly demonstrate two different methods of using speed lines. The first example depicts a character running toward the camera. The second one is used to show a character vanishing into the distance.

What defines anime? The characters, the humor, the cultural references, and above all, the artistic style. Anime's flamboyant visuals are now universally recognized, but it is not all just big "anime eyes" and "kawaii" kitsch. The visual grammar of anime goes a lot deeper than appearances may first suggest.

A huge part of what makes anime recognizable is the Japanese sense of hyper-stylized characterization and expressions.

In fact, anime is so uniquely Japanese that it occasionally alienates the uninitiated. Those affiliated with Japanese society and customs (or those who fervently follow them) are usually more in tune with this hyper-real, often slapstick approach to characterization and humor. To put it simply, the more knowledge you have of Japanese culture, the better you are equipped to decipher the hidden meanings behind the visual grammar.

- **Using stylization to add authenticity**
- **Understanding the visual language**

92 VISUAL GRAMMAR

Hyperstylization

Hyperstylization refers to the excessive embellishment of character expressions and actions, and is one of anime's most recognizable trademarks. This fundamental visual tool is not only vital in establishing characters' personalities and generating humorous situations, but it also gives the onscreen exploits a flamboyant burst of energy. In fact, hyperstylization is so much a part of anime that you will scarcely come across a show without some traces of it.

To make your work look more authentic, there's really no avoiding the use of hyperstylization. To get a better idea of what to expect, study existing anime shows, particularly comedies, such as *Love Hina* and *Azumanga Diaoh*, which are full of over-the-top expressions.

Here's a guide to some of the more popular examples of hyperstylization, and explanations of their quirks.

▼ Sweatdrops

For the uninitiated, the oversized sweatdrop is possibly the single most baffling piece of visual grammar. It has a range of meanings, all of which are more subtle than its appearance suggests. Primarily it represents embarrassment or nervousness, as people sweat when under pressure, which is the most literal interpretation. Sometimes it is used to represent incredulity, a silent reaction from someone who is confused by what they see. It is also commonly used to indicate someone discrediting another person's actions, comparable to a sucking of the teeth or a shake of the head.

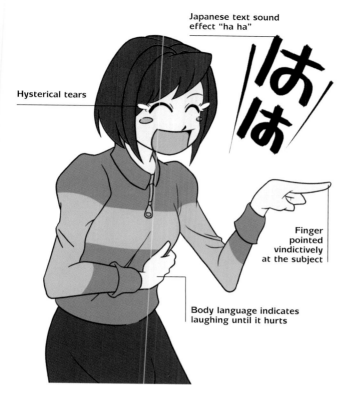

Japanese text sound effect "ha ha"

は
は

Hysterical tears

Finger pointed vindictively at the subject

Body language indicates laughing until it hurts

▲ **Side-splitting laughter**

In anime, eyes are often illustrated as little arches to convey a character's elation. In this example, the character is not only elated but also bursting with uncontrollable laughter, her finger pointing toward the object of her amusement. This is a classic pose for situations where someone is getting enjoyment from another's misfortunes.

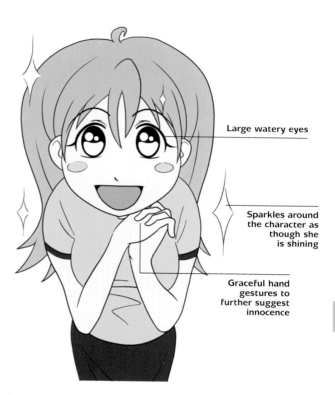

Large watery eyes

Sparkles around the character as though she is shining

Graceful hand gestures to further suggest innocence

▲ **Gleaming eyes**

A very common hyperstylization that is usually used to signify a character being besotted with someone or something, typically a young girl with a handsome man. It can also be used when a character is attempting to feign innocence, in order to get his or her way.

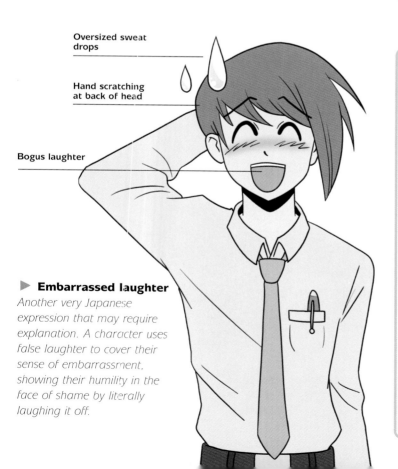

Oversized sweat drops

Hand scratching at back of head

Bogus laughter

▶ **Embarrassed laughter**

Another very Japanese expression that may require explanation. A character uses false laughter to cover their sense of embarrassment, showing their humility in the face of shame by literally laughing it off.

Sweatdrop

1. *Begin by fading in a static image layer of a sweatdrop on the side of a character's head.*

2. *Motion tween it (see Keyframes, page 56) downward a small distance, as shown in the example. Play around with the sweatdrop idea by changing its size or adding more in.*

Dread

1. *This is a simple yet effective anime visual shorthand. Start by drawing vertical lines of varying lengths going downward (like dripping paint) on a separate layer. Now place this object out of the top of screen.*

2. *Slowly motion tween it downward into view as though it is black slime slowly enveloping the scene.*

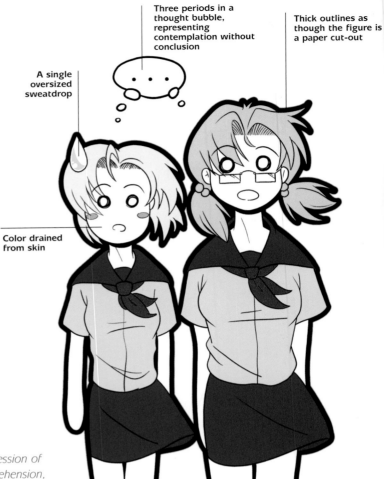

Three periods in a thought bubble, representing contemplation without conclusion

Thick outlines as though the figure is a paper cut-out

A single oversized sweatdrop

Color drained from skin

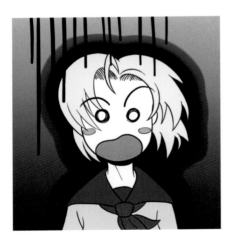

▶ **Shocked stare**

An exaggerated expression of disbelief and incomprehension, mostly used when a character is involved in breaking a social taboo.

◀ *A more overt look of shock—bordering on horror.*

Arching eyebrows showing discomfort

Exaggerated "rivers" of tears

A tightly closed and slightly quivering mouth, a display of restraint

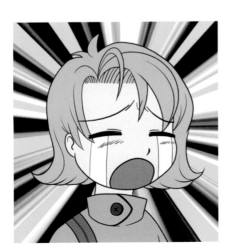

▶ **Crying rivers**

An expression with multiple meanings. The most obvious explanation is that the character is crying over a misfortune. Conversely, it is used to express a character's extreme joy, overwhelmed to the point of tears.

◀ *Here, the character is crying without restraint, as represented by the wide-open mouth.*

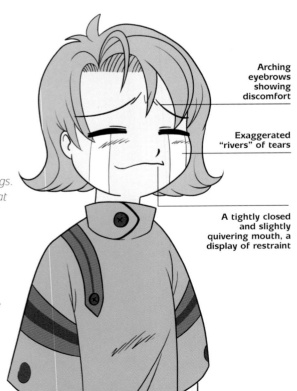

▼ Fatigue or resignation

A hefty sigh used to illustrate a character's physical or mental exhaustion. The little mushroom cloud that is released by the sigh has long been the default icon for this expression.

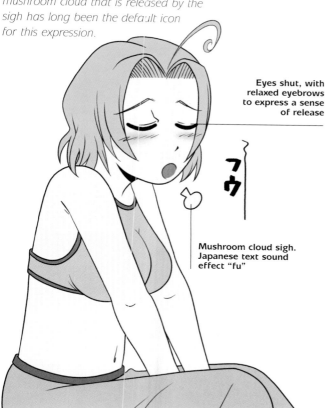

Eyes shut, with relaxed eyebrows to express a sense of release

Mushroom cloud sigh. Japanese text sound effect "fu"

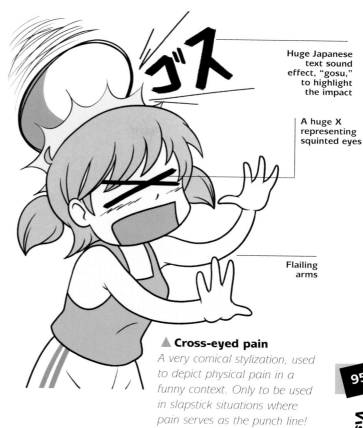

Huge Japanese text sound effect, "gosu," to highlight the impact

A huge X representing squinted eyes

Flailing arms

▲ Cross-eyed pain

A very comical stylization, used to depict physical pain in a funny context. Only to be used in slapstick situations where pain serves as the punch line!

Cross-type symbol, represents throbbing veins

Scribbles indicate discontent

Fist clenched and shaking

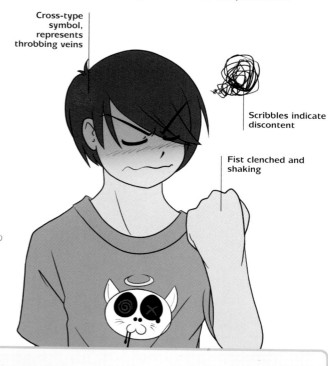

► Muted rage

You will come across this expression regularly. It represents a character's quiet build-up of anger before inevitably exploding with a climactic burst of fury. Traditionally, the character will do this with his back to the subject who's causing the grief.

◄ *Here, the same character gets even angrier!*

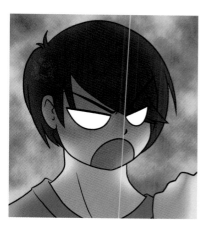

Pulsing veins and scribbles

1. *Draw in the veins and scribbles on a separate layer.*

2. *On the next frame, redraw both objects. To make the veins look as though they are pulsating, vary the size from small to big, and to make the scribbles look like puffing black fumes, redraw them in a slightly different way. By flitting from the previous frame to this one, you will achieve a very simple animated effect.*

"Anime eyes" have long been the distinctive element that separates Japanese animation from all other kinds of animation. They have become iconic in popular culture and plagiarized by countless contemporary designers and artists. While the use of these impossibly large, glistening eyes is not really enough to completely define anime, they do a good job of conveying the saccharine-sweet cuteness that typifies much of anime's output, so much so that it would be hard to imagine anime without them.

■ **How to draw expressive eyes**
■ **Animating eye movements**

ANIME EYES

▲ **Lighting** *In all their full glory, anime eyes can be strikingly beautiful. In this example they are emphasized to dramatic effect by the use of lighting effects (see page 76).*

Creating beautiful eyes

There are many different ways in which you can create anime eyes, and a quick look at a variety of anime shows will reveal that most artists have their own individual approach to the subject (even more so with manga). Don't feel you have to follow our examples exactly—instead, use them as a rough guide and the inspiration for developing your own style and technique.

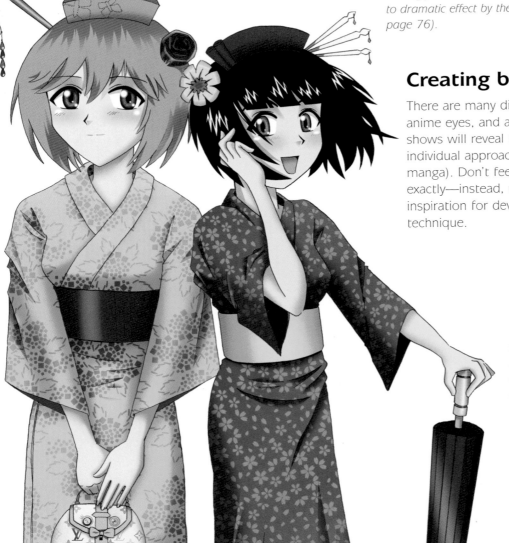

◄ **Romantic eyes** *In a romantic shojo-type show, eyes are more important than ever. Here the allure of the protagonists' eyes is matched only by the beauty of their faces.*

Begin your design with the line art, using a pencil—or if you feel confident, black pen or ink brush. Keep the drawings as simple as possible at this stage. Once you have drawn the basic outlines, fill in the whites of the eyes and add some shading under the eyelid. Follow this by coloring the eyebrows, using a slightly darker tint of the hair color. Now for the iris. Start by choosing an eye color that complements the rest of the character's color scheme, and fill the iris with it. Select a slightly darker shade of the iris color and apply it around the outer edge of the iris, as shown in the third step of the example. Finally, add the light reflections. These will give your eyes that all-important shiny look, and a greater sense of depth that was previously missing.

Drawing eyes

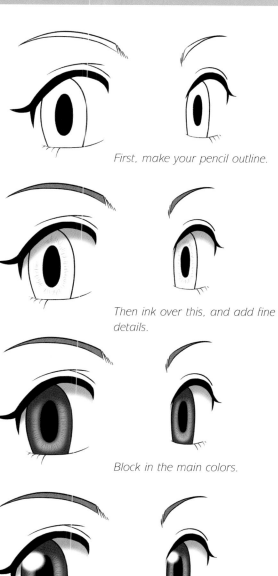

First, make your pencil outline.

Then ink over this, and add fine details.

Block in the main colors.

Finally, add highlights and shading.

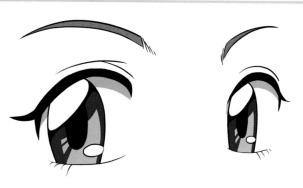

Beautifully detailed, these eyes would be very labor-intensive to produce in significant volumes.

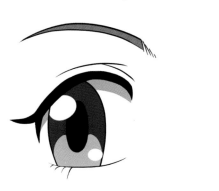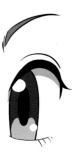

With clean, simple color fills, these are typical anime eyes.

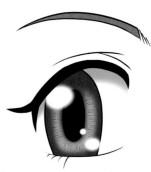

These eyes are made for close-ups!

Different styles

There are countless ways to draw and render eyes in anime. The method used in the previous example is one approach. Above, three distinctly different approaches are illustrated, all using the same base drawing. The top example depicts a detailed and complex approach, the kind synonymous with manga and one-time still images. The middle one is closer to what is typical of anime; a cleaner, simpler technique using areas of flat color, which is more suited to producing the volume of coloring that animation demands. The final approach is a soft airbrush look, beautifully rendered and excellent for close-up shots.

Using eyes to define character

Eyes (and eyebrows) have always been used in comics and cartoons to identify a character's personality. Common character stereotypes are instantly recognizable: the villain, with slanted, menacing eyes and brows; the little girl, with big, innocent eyes; the hero, with an ever-determined gaze; and so on. Anime is no different, although the archetypal conventions are shifted slightly due to cultural differences. Don't be afraid to deviate from the norm when designing your characters. Evil eyes don't always have to result in an evil character.

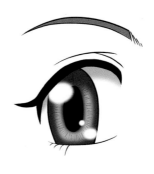

▲ **Neutral-looking eyes**
These are standard-issue anime eyes that have no specific character traits attached to them.

▲ **Meek-looking eyes**
These eyes are suitable for a character who is shy, or someone who is in the process of grieving.

▲ **Tired-looking eyes**
These eyes are suited to a character that is lethargic, or just blasé about a situation.

◄ **Oversized child's eyes**
These are more commonly used for children or super-deformed "chibi" characters (see page 100).

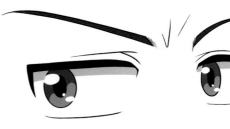

▲ **Serious eyes**
These are more commonly associated with adult characters, or those who are more serious and studious in nature.

◄ **Sexy eyes**
The kind that would be fitting for a seductive female character, perhaps more mature, and oozing with sexuality.

◄ **Unembellished eyes**
Appropriate for more realistic-looking characters.

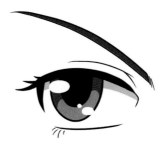
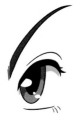

▲ **Stern eyes**
Spirited and determined-looking, these are fitting for a noble action hero or, conversely, a resolute villain.

Animating eyes

There are two distinct ways of animating eye movements—the eyes-open roll and the blinking roll. Though the eyes-open roll is easier to implement, it is the blinking roll that mimics most accurately the way we roll our eyes, since humans tend to shift their vision in the middle of a blink in an almost unnoticeable fashion.

The eyes-open roll

1. *Begin with a fully rendered character with a pair of empty eye sockets.*

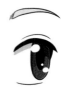

2. *On a separate layer, add in the irises and pupils.*

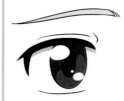

3. *Move the pupils around in the direction you desire.*

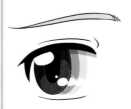

4. *The pupils will now successfully shift from left to right.*

The blinking roll

1. *This method requires the complete eyes to be drawn in on one layer.*

2. *The action of a blink is so fast that it is not really necessary to animate more than a few frames. Here, the eyelids are half shut on their way down, with the pupils to the left.*

3. *Now the eyes are fully closed.*

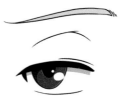

4. *Here, the eyelids are half open on their way up. Notice how the pupils have been shifted to the right. This gives the impression that they were shifted during the blink.*

5. *The eyes are now fully open, with the pupils shifted.*

▪ **The term "super-deformed"** (or "SD") refers to the miniaturization of characters, in a bid to make them as child-like and adorable as possible. "Super-deformed" is also known as "chibi," which translates as "little" in Japanese.

Most well-known anime characters have, at one time or another, been given the SD treatment, either by the creators or by zealous fans. Characters are usually "SDed" as a way for artists and fans to lampoon the franchise, and show the characters in an entirely contradictory context. For example, the fierce giant robots of the Gundam series have spawned an independent by-product with their SD

caricatures. They are popular because long-term fans find it refreshing to see familiar designs so cheekily revised, doing things they normally wouldn't do in their full-sized versions (usually something silly that the original franchise would never allow). SD characters are great source material for toy and figurine manufacturers, who exploit their cuteness to reach a potentially broader audience.

100 SUPER-DEFORMED

▪ **Creating SD characters**
▪ **Developing logos and motifs**

There's no hard and fast rule for making SD characters, and individual artists have their own interpretation of what makes the best SD. Generally, cuteness is what you should be aiming for when drawing in this style. If it looks adorable and full of infantile charm, then you're on the right track.

▶ **Typical SD characters** *Notice the oversized heads, compared to the way the rest of the body has been scaled down. This anatomic disproportion is crucial to SD character design, because this is what gives them their childlike appearance, and makes them cute. Also, notice the simplification of body elements, such as hands and feet. This is common practice when creating SDs, where the idea of "less is more" really works. Leave out anything that is overly elaborate, and emphasize or exaggerate prominent character features.*

▶ *By way of comparison, these are the same characters in their original form. Most super-deformed characters originate from existing characters, and serve as a good way for artists to play around with and caricature their creations, giving more flexibility to use them in different situations.*

Super-deformed as motifs

Given the chibi characters' adorable and strikingly bold looks, they are often used as design motifs and logos for marketing, rather than as actual anime characters. Of course, there are a number of shows that push the SD format as their main selling point (*Bottle Fairy*, *Scramble Wars*, and *Powerpuff Girls*), but these are exceptions rather than the rule. In general, their use is limited to punctuating moments, and usually for comedic effect.

When applied effectively, SD characters can add to your production. They make great motifs for title sequences, idents, and skits, and can really inject a sense of fun to the onscreen antics. *Teen Titans Go!* is a good example of how this has been adapted to a western animation.

◀ ▲ **Extreme SD characters**
These examples show some extreme SD characters, where their disproportionate bodies are taken to a new level, in order to make them distinctly eye-catching. This look is further enhanced by thick black outlines and the use of bold primary colors, making them esthetically closer to brand logos than actual characters.

◀ **SD animals**
In anime, domestic animals, such as cats and dogs, are often portrayed in a rather hyper-real SD style, even if the rest of the cast isn't (for example, Kiki's Delivery Service). This is because the creators want to show pets as being very cute and cuddly, and what better way to achieve this than to portray them in a chibi style?

PRODUCING ANIME

The days of painting on cels and capturing them on film have all but disappeared. The advent of digital animation has opened up possibilities for talented artists to create their own movies, free from the restrictions imposed by the demands of equipment. Creating digital anime does require the right software to get the job done, though, whether you are working in 2D or 3D. "Right software" does not mean that there is just one package that should be used above all others—it's just the program(s) you are most comfortable working with and which get the job done without stifling your creativity.

The following pages are a guide to the different types of software available, and give some suggestions to get you started without going to great expense.

There are many packages available, ranging in price from free to thousands of dollars. With technological advances, today's free programs can have more features than some of the expensive commercial ones of less than a few years ago. In fact, a lot of creative computer magazines include CDs with a free older version of a current release, so before you go spending lots of money it is worth having a look at your local newsstand.

If you are working in 2D, you will need a program to color your images, then something to put all those images into a sequence. For 3D, a program that lets you model, texture, animate, and render is required. You will also need to edit sequences together and add sound. If you want to integrate 2D and 3D, you will also need compositing software. This mixing of the two different digital media is very popular in anime (e.g. *Ghost in the Shell* and *Sky Blue*, with *Sky Blue* adding some stop-motion into the mix), allowing inorganic objects to be created in 3D with the organic characters being drawn by hand. Here's a breakdown of popular packages.

Choosing the right tools

Pros and cons of different software packages

PRODUCTION OPTIONS

Software name	M or W	$	Primary functions	Pros	Cons
Photoshop	Both	$$$$$	Image editing	Standard image editing program. Very powerful.	Not designed for animation.
ImageReady	Both		Create web-ready images	Part of Photoshop installation. Good timeline animation for GIF.	Limited to web-based pixel animation.
Fireworks	Both	$$$	Create web ready images	Integrates well with Flash and Freehand. Easy to use.	Limited to web-based pixel animation.
Corel Painter	Both	$$$$	"Natural media" image editor	Emulates natural media. Great for backgrounds. Built-in animation tool.	Needs graphics tablet.
Dogwaffle	W	$	"Natural media" image editor	Emulates natural media. Great for backgrounds. Built-in animation tool. Price. Free version available.	Limited export options.
Freehand	Both	$$$$	Vector illustration	Intuitive to use. Integrates well with Flash.	
Illustrator	Both	$$$$	Vector illustration	Integrates with other Adobe products.	
QuickTime	Both	Free	Movie playback on computers	Default standard for video on computers. Pro version gives export options.	
iLife	M	$	Editing, music	Integrated music and video creation. Price. HD.	Limited video and audio tracks in iMovie.
Final Cut Express	M	$$$	Editing, music	Low cost for pro-level video editing and music creation. HD.	Doesn't import image sequences very well.
Shake	M	$$$$	Compositing and effects	Extremely powerful pro-level tool. Price.	Needs powerful computer.
Premiere Elements	W	$$	Video editing	Low cost and easy to use.	Limited functionality.

Name	Platform	Price	Category	Pros	Cons
Premiere Pro	W	$$$$$	Video editing	Can import image sequences to make animation.	
AfterEffects	Both	$$$$$	Compositing and special effects	Integrates with other Adobe products.	
Adobe Production Studio	W	$$$$$	Complete video package	Everything you need to make professional-level movies.	
Flash	Both	$$$	Image generating and comping	Capable of pro-standard animations. Files are small, so suitable for internet. SWF format is web standard.	
Toon Boom	Both	$$$$	Vector animation	Emulates traditional animation methods. Multiplane camera. X-Sheet. Student version available.	Needs graphics tablet.
Animation Stand	Both	$$$$$	Digital animation	Emulates traditional animation methods. Multiplane camera. X-Sheet. Auto cel painting.	Relatively unknown.
Monkey Jam	W	Free	Pencil Test	Full feature range, including x-sheet. Price.	Cannot be used for painting.
Toki Line Test	Both	$$	Pencil Test	Full feature range, including x-sheet. Sound.	Cannot be used for painting.
DigiCel Flipbook	Both	$$$$$	Digital Animation	Emulates traditional animation methods. Multiplane camera. X-Sheet. Auto cel painting.	
Toonz	W	$$$$$	Digital Animation	Emulates traditional animation methods. Multiplane camera. X-Sheet. Auto cel painting.	Designed for use in large studio.
Retas! Pro	Both	$$$$$	Digital animation	Modular suite of integrated professional tools.	Designed for use in large studio.
Animo	Both	$$$$$	Digital animation	Modular suite of integrated professional tools.	Designed for use in large studio.
TAB	Both	$	Vector animation	Emulates traditional animation methods. Multiplane camera. X-Sheet. Price.	Needs graphics tablet.
Stylos	Both	$$$$$	Vector animation	Emulates traditional animation methods. Multiplane camera. Storyboard. X-Sheet. Designed for anime.	
Daz\|Studio	Both	Free	3D character tool	Price. Easy to use. Lots of low cost anime content. Helps with modelling and drawing 2D.	Animation tools limited.
Poser	Both	$$$	3D character tool	Easy to use. Lots of low cost anime content. Helps with modelling and drawing 2D. Good animation tools.	Steep learning curve to get poses correct.
Carrara	Both	$$$$	3D animation.	Imports characters from Poser and DAZ\|Studio. Excellent features for the price.	Non-standard interface.
Mimic	Both	$$	Lip-synching	Easy way to get good lip sync with 3D.	Limited to Poser and Lightwave 3D.

Animation is simply a sequence of consecutive still images, played back at a speed that tricks the eye into thinking it is seeing one continuous movement. To create this effect using digital technology, you will need one program to make the images and another to run them in sequence. At the most basic level, you need very little in the way of equipment, either hardware or software. Before the advent of computers, drawing images in the corner of a book and quickly flipping or thumbing the pages was the easiest way to make a simple animation. You can make your first digital anime with your computer with very little or no outlay.

GIF giving

The simplest forms of digital animation is the animated GIF (Graphic Interchange Format). GIF files work with limited color palettes and don't handle continuous tone very well, which is ideal for producing cel-shaded images. Unfortunately, there are limitations: you are restricted to showing it on the web, which can be hampered by file sizes and connection speeds. If you see the format as a digital flip book, it is a good place to start, however, and there are plenty of freeware and shareware tools available, quite apart from commercial applications like Macromedia Fireworks or Adobe ImageReady (which comes with Photoshop).

DIGITAL BASICS

- ## Understanding different formats
- ## Creating simple animations

Image-generating programs

You will need a program to create and modify your frames, which are called image-generating/image editing programs. You can scan hand-drawn pencil sketches and import the scans into the software for inking and coloring. When scanning pencil drawings use a resolution of at least 300 dpi, and retain this for coloring. When the image is ready for exporting reduce it to 72 dpi at one of the screen resolutions listed in the adjacent tip box. Remember to always work in RGB mode.

Even though Photoshop is great at producing still images, it does not make animations on its own. It does, however, integrate very well with Adobe Premiere (or the more expensive After Effects), which will allow you to import a batch of Photoshop files and, providing they are consecutively numbered, create a sequence. Despite its ubiquity, however, Photoshop is not the only program available. Alternatives such as Corel Painter or Dogwaffle offer some unique "painting" methods and built-in animation tools. When you begin to make animation, adapting existing tools is a great way to start, but if you are serious about making animation, then a dedicated package will be a better choice. These are covered on page 108.

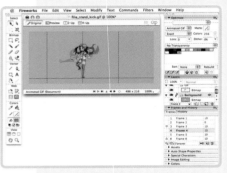

Image editor *Fireworks is an image editor designed to work with web graphics. Its animated GIF function is a useful way of learning the principles of frame-based animation; although the applications of the output are limited to web sites.*

Animator's tip: Resolution

Pixel-based image editors use tiny bits of digital information, called pixels, to build up the picture. Each pixel represents a single dot, so pictures created with these types of programs are resolution dependant. The quality of the image is decided by the number of pixels (dots) per inch, or dpi, although for video and movies there are specific resolutions and ratios that have to be used. An NTSC Digital Video (DV) frame is 720 x 540 pixels (768 x 576 PAL) which is a ratio of 4:3. The new HD (high definition) format has a resolution of 1920 x 1080, an aspect ratio of 16:9. All images should be saved at 72 dpi, no matter which format you use.

Resolution 25 dpi Resolution 72 dpi Resolution 150 dpi Resolution 600 dpi

Most people interested in visual arts are familiar with Photoshop or its consumer version Photoshop Elements as a way of manipulating digital photos, but it has a host of drawing tools too.

What you get with a graphics program

Most image editing programs offer a similar set of tools and functions, along with their own unique features. Familiarity with one makes learning others that much easier. These are the common tools in Photoshop.

Magic wand

Crop

Eraser

Text

Pen

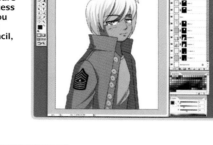

The toolbar is a standard feature of all graphics software and gives you access to all the tools you need for drawing and painting (pencil, pen, brush, fill).

Layers are an important part of any graphics program. The can be used for assigning colors or individual elements. They can also serve as a lightbox for tracing.

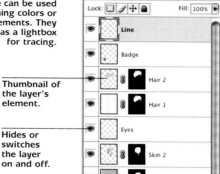

Thumbnail of the layer's element.

Hides or switches the layer on and off.

Layer mask, which covers all the image in the black area for that layer.

The color mixer is where you create new colors for your project. For animation, this should only be done in RGB mode. Colors can then be added to the Swatch palette.

Unique swatches can be created for your project and saved for use within each new file. This creates absolute consistency of color throughout. Colors are dropped onto the swatch palette from the mixer.

Platforms

When selecting software, it is a good idea to choose programs that are cross-platform and have versions for both Mac and Windows. Because of the sheer volume of work involved in making even a short animation, collaboration is very important. While most of your friends will probably work with the same operating system, you can never guarantee it, so ensure the compatibility issue is considered when choosing your package. The majority of software developers will produce at least two versions of their programs, with some doing Linux as well.

Most developers also produce demo versions of their products so you can try before you buy. They will usually have some sort of restrictions on them, such as time-limited, feature- and save-disabled, watermarked, or reduced resolution, but it will give you a chance to see if they do what you want in a way you are comfortable with. This will often be dictated by the user interface. For example, Adobe software shares a common interface, so that, if you are familiar with Photoshop, using their other programs becomes easier and more intuitive. The programs are also closely integrated for file exchange.

▲ **Web-ready images** *Like Fireworks, Image Ready produces web-ready images and is included in the installation of Photoshop. As it is part of the Photoshop package, it integrates seamlessly, with any changes made in one program affecting the other. Its animation tool is very easy to use.*

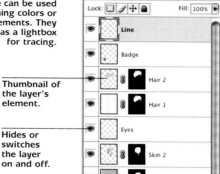

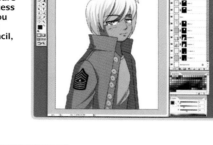

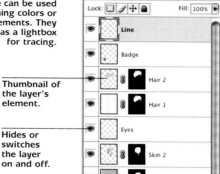

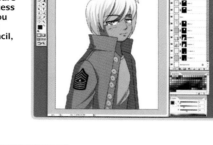

Although there are plenty of ways to create anime using your existing or low-cost software, if you want to produce professional-looking results, or simply increase your chances of working in an animation studio, then you have to look at dedicated animation software. For 2D you have a choice of pixel- or vector-based programs, and although most now incorporate both technologies, it is still important to understand the basics of each.

- **Choosing animation software**
- **Creating cel animation digitally**

▲ **Toonz** *A major player in the world of professional digital animation, Toonz is a sophisticated program, designed to accelerate the workflow in a studio. This shows how the x-sheet integrates with the system's other modules. Studio Ghibli favor Toonz for their animations.*

108 DEDICATED PACKAGES

Dedicated advantages

The advantage of using a dedicated animation package is that it is designed to emulate the traditional cel-animation methods, but with the bonus of added efficiency and, more importantly, the ability to make major amends without having to redo weeks or months of intense labor. For the individual animator or small studio, these packages are a great boon because one person can do the work of many people, thereby reducing production costs. While this cost saving is also advantageous to large studios, it does mean that apprenticeship schemes have been all but eliminated.

Modular cycles

Most of the dedicated packages come in modules that make the production workflow a lot smoother by sharing the tasks. These modules are usually divided into tasks: scanning (for digitizing pencil-drawn frames), pencil test, tracing (inking), painting, and compositing/camera. Tracing/inking is now almost exclusively done digitally, because it has the advantage of "undo" and the capacity to duplicate frames, saving unnecessary repetitive work.

Color palettes can be standardized and available to everyone working on the project, and any palette changes can be automatically updated through the whole project.

Integrated x-sheets

Working with an integrated x-sheet further simplifies the process and allows you to make on-the-fly adjustments, such as changing running order, because the individual frames and layers are attached to it. A common anime

▲ **Dogwaffle**, *despite its strange name, was created as a pixel-based painting tool, with animation in mind. Although it is not a true dedicated animation program, there is a free version of it, as well as a full-featured commercial one.*

trick is to use the compositing/camera component to add movement without having to do lots of extra drawing.

While top-end packages are priced for pro studios, Animation Stand and DigiCel FlipBook cost less than a full version of Photoshop and do everything you need to make your animation. Some are designed to work from pencil-and-paper originals, but most can work with direct input from a graphics tablet. If you want to use a purely digital system, you should think about using a vector animation system—these are covered on the next page.

Dedicated animation software comes in all shapes and sizes (and prices). Many are multipart modular systems and others have everything integrated into a single package.

What you get with a dedicated program

Retas! Pro *is Japan's biggest-selling studio animation software and is produced locally. Being a professional package it is priced accordingly and comes in several modules. CoreRETAS is the heart of the system where all the elements are brought together using the x-sheet and the camera.*

The x-sheet is the heart of the system. Each frame is numbered, the camera position is inserted in relation to image on each layer.

The camera position and magnification is controlled here. The information set here is inserted into the x-sheet, and vice versa.

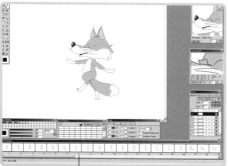

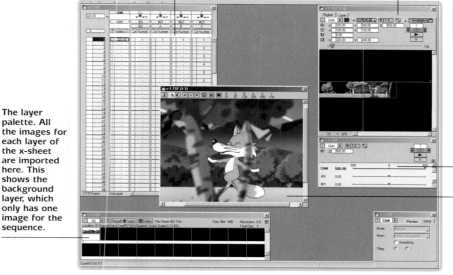

The layer palette. All the images for each layer of the x-sheet are imported here. This shows the background layer, which only has one image for the sequence.

Paintman is the ink and paint module of RETAS! Pro and is linked to CoreRETAS for an integrated workflow.

Further camera controls.

Preview window, which shows how each frame looks with all the layers integrated.

DigiCel FlipBook *This is a relative newcomer to the scene, but is gathering a solid following, mainly due to its keen pricing and range of features. Its simplified interface makes working a lot easier and more intuitive. The x-sheet is at the heart of the system.*

All the tools needed for a digital workflow are accessed from this toolbar. A new screen is presented for each tool.

The x-sheet controls each layer of the animation on a frame-by-frame basis. For people coming from a traditional cel animation background this is a more natural way to work than with timelines.

The color palette can be shared across the whole project.

A standard range of ink and paint tools.

Suggested software

Always check that software is suitable for your platform before you pay for it!
Animation Stand:
www.animationstand.com
FlipBook: **www.digicel.net**
Retas! Pro: **www.retas.com**
Solo: **www.toonboom.com**
Toonz: **www.toonz.com**
Animo: **www.animo.com**

Vector image 100%

Vector image 400%

Bitmap image 100%

Bitmap image 400%

Vector versus bitmap
These images demonstrate the way in which a vector image can be enlarged without loss of quality, whereas a bitmap image deteriorates. Bitmap images allow subtler gradations of tone, however.

🔲 **Vector illustrations** and animations take a completely different approach to creating images than does pixel-based software. Vectors rely on mathematical calculations to produce lines and fills, rather than the bits and bytes of pixel programs. Vector art has traditionally been distinguishable from pixel art by its clean, precise lines and solid, flat colors, making it an ideal medium for anime. But its advantages don't stop there. Vector art is resolution independent, which means it can be enlarged or reduced to any size without loss of quality. It also keeps file sizes much smaller. Another advantage of vector software is that every element on the page always remains fully editable, unless it is converted to pixel format within the program for applying certain filters or effects.

110 VECTORS

🔲 **The advantages of vector software**
🔲 **Finding a program to suit your style**

Different strokes

Vector software has developed enormously since its origins as a tool for creating logos. Today, programs like Adobe Illustrator, Freehand, and Expression can imitate all types of brush strokes, with Expression doing the best job of simulating natural media. Vector illustrations are ideal for creating the toon-shaded images found in most anime, because shapes are filled with solid colors. Most vector software now offers transparency options, which help make shading easier. Changing colors is also simplified, since lines and fills are allocated colors from a palette that can be edited for global changes. Alternatively, styles can be created for individual elements and edited when required. Using one of these illustration packages is a good place to start creating your characters before you begin the actual process of animating them.

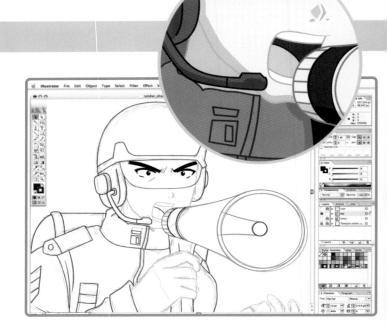

▲ **Adobe Illustrator** *This and other illustration programs are better adapted to drawing than Flash. A scanned pencil drawing can be imported as a template, then redrawn and colored. Using multiple layers helps when adding cel shading.*

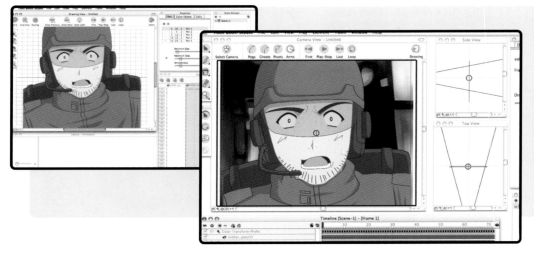

◀ **Toon Boom Studio** *This fully featured animation program is divided into two parts. The drawing section is for creating the individual frames, which are added to the interactive x-sheet. The scene section serves as the camera and compositor and features a 3D multiplane camera and the common timeline seen in other animation software.*

Export in a Flash

Many 3D programs can export as vector or Flash files. Both Toon Boom Studio and Flash work with layers, and the 3D elements can be placed in the files to work in conjunction with 2D drawings. Because the layers in Toon Boom emulate 3D space, allowing the camera to move through a scene, this will give added depth to your animation, even if you don't utilize 3D models.

There is another curiosity in the world of vector animation, Moho. This program uses skeletons, like those in 3D animation, to create movement. Because of the way it works, it does tend to favor stylized characters to make the most of its features, which could make it ideal for chibi-style anime.

▲ **Flash** *This uses a basic timeline method of creating animation, where frames can be added one at a time or movements created with built-in functions like motion tweening. Vector images can be drawn directly onto the stage or imported from an illustration program, such as Freehand.*

Vector victorious

All the advantages of vector art serve the anime artist very well. Because all the elements remain editable, copying and adjusting them between frames speeds up the way you work, especially if used in conjunction with the layers functions. Some amount of automatic tweening is also possible, although not to the same degree as with 3D software.

There are two packages in particular that are powerful, fully featured, and affordable: Macromedia Flash and Toon Boom Studio. The Flash file format has become the default for internet animations. Originally designed to create complex animated banners in tiny file sizes, it has become a powerful development tool for animation, websites, and online games. For anyone simply wanting to make animations, its sophisticated features may be a bit of an overkill.

Toon Boom Studio, on the other hand, is designed to emulate a traditional approach to animation, complete with tools such as x-sheets, rotating light box, and multiplane camera. It even comes with preset mouth shapes for lip-synch, which will speed up the production. Toon Boom Studio comes in two versions, the entry-level Express (at under $100) and the full version. For anyone wanting to make a career in animation, this is an excellent place to start, as Toon Boom also produces professional-level programs used in major studios around the world.

▲ **Stylos** *This is a dedicated vector animation program from the makers of Retas! Pro. It has all the features a serious animator will need, from storyboarding to x-sheet to drawing, painting, and camera, which are all integrated. Coming from Japan, it is well suited to anime.*

Software links

Always check that software is suitable for your platform before you pay for it!
Illustrator: **www.adobe.com/illustrator**
Freehand: **www.macromedia.com/freehand**
Corel Draw: **www.corel.com**
Canvas: **www.acdamerica.com**
Expression: **www.microsoft.com/expression** (Version 3 is available as a free download)
Flash: **www.macromedia.com/flash**
Moho: **www.lostmarble.com** (Papagayo, a free lip-synch tool, is also available here)
Stylos: **www.celsys.co.jp/en/retas/index.html**
TAB (Toonz Animation Board): **www.the-tab.com**
TAB Lite: **www.tablite.com**
Toon Boom Studio: **www.toonboom.com**
Toonz Harlequin: **www.toonz.com**

3D originally referred to stop-motion animation using puppets and models, but the use of this technique is diminishing, partly because of its time-consuming nature, but also because of the huge advances in computer technology. When we talk about 3D nowadays, it is generally accepted to mean CGI (Computer Generated Images), or simply CG. 3D CG has become such an integrated part of animation that vast parts of seemingly 2D animation are created with toon-rendered 3D images.

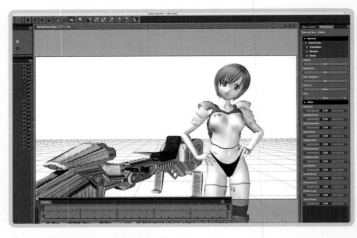

▲ **Customizable models** *Daz|Studio is a character-based illustration and animation program that uses customizable models. The animation tools are a basic keyframe–timeline arrangement, but it is the range of clothes and props that makes it a worthwhile tool.*

- **Working in three dimensions**
- **Integrating 2D with 3D**

112 3D SOFTWARE

Body building

3D software is ideal for creating inorganic objects such as robots, vehicles, and buildings. Making humans, on the other hand, requires not only excellent modeling skills but also an exceptional knowledge of anatomy, far beyond that required for drawing, because 2D can be highly stylized to disguise any obvious shortcomings.

To make an anime really interesting, it needs to have human characters. For beginners, intermediate, and even advanced animators, the easiest way to introduce humans is with a program like Poser or DAZ|Studio. These are programs specifically designed to work with human forms and they come with an assortment of readymade characters. With the rise in popularity of anime and manga, several characters have been created in that style, such as Aiko (female) and Hiro (male) from DAZ. These base figures can be highly individualized using a huge array of settings within the programs and, with the addition of other elements such as hair and clothes, truly unique characters can be created.

Both DAZ|Studio and Poser come with animation tools built in, and they utilize a keyframe and timeline system, like most digital animation software. Because the characters are anatomically correct and fully jointed, they can be moved into any pose (hence the name of the original program).

Creating realistic poses can be a long and arduous task—but all manner of readymade poses, from martial arts to flirting, are available to buy and/or download and can serve as the basis of keyframes. DAZ also produces a program called Mimic that will create lip-synching from sound files for use with Studio, Poser, and Lightwave.

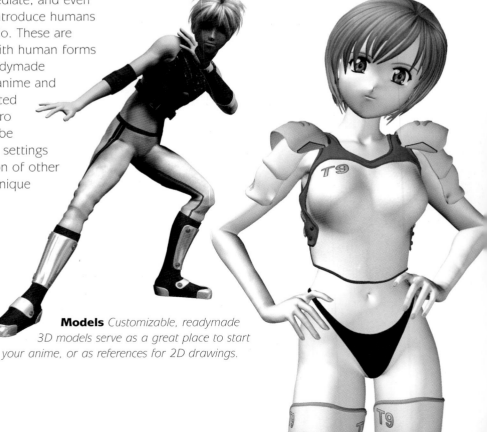

Models *Customizable, readymade 3D models serve as a great place to start your anime, or as references for 2D drawings.*

▲ **Poser** *This original character-posing software has developed a range of complex features that help with animation. It uses a keyframe–timeline system, but offers a sophisticated editing system for fine-tuning the animation. Its walk designer lets you create walking and running sequences with a few mouse clicks.*

▲ **Carrara** *A software package that comes in three versions (Basic, Standard, and Pro), which allow you to import whole animated scenes from Poser and render them with a good toon shader or convert them to vector animations. Complete characters and animations can be created from scratch with its modeling tools.*

Rendered in the shade

Although Studio and Poser excel at character animation, they don't have the best tools for creating original backgrounds, nor do they offer the best rendering options. Studio has a basic toon render, but it is not as flexible as some of the dedicated 3D packages. Because of the quality and popularity of these two character programs, many other 3D programs offer ways to integrate them. Studio is designed to work with landscape generator Bryce, while complete Poser animations can be imported into applications such as Carrara, Lightwave, and Vue. Carrara, or its entry-level version 3D Basics, is an excellent choice for anyone starting in 3D, with a great price-to-features ratio. Its interface is a lot friendlier and more intuitive than many other 3D applications.

When you take into consideration that all 3D programs work on the same principles of building and manipulating shapes and adding textures to them, then beginning with a program like Carrara will let you get started without going to great expense. Many of the professional-level packages, such as Maya, are available as free demo or training versions, with limitations put on the size of the renders. It is a great way to learn how to use them, but the learning curve is very steep.

When selecting a 3D package, make sure it will create animation, preferably using keyframes and a timeline. Some other features to look out for are particle engine, animated cameras, terrain modeler, inverse kinematics, cartoon rendering, and exporting to Flash format.

Overall, if you want to integrate 3D into your anime toolkit, choose a program you are comfortable using that lets you achieve your intentions for the final output.

▲ **Lip synch software** *Mimic takes a sound file of a voiceover and converts it into a properly lip-synched animation. It works with Poser or Studio characters, and the completed file is added to the Poser or Studio animation for exporting.*

Software links

Always check that software is suitable for your platform before you pay for it!
DAZ|Studio and Bryce: **www.daz3d.com**
Poser and Vue: **www.e-frontier.com**
Animation:Master: **www.hash.com**
Carrara: **www.daz3d.com/carrara**
Cinema 4D: **www.maxon.net**
Electric Image: **www.eitechnologygroup.com**
Lightwave: **www.newtek.com**
Maya: **www.autodesk.com/maya**
3DS Max: **www.autodesk.com/3dsmax**
Messiah: **www.projectmessiah.com**
Soft Image: **www.softimage.com**

Special effects are part of nearly every live-action movie made these days, often at the expense of the story or characterizations. In live-action films, special effects are generally created with animation, either 3D CGI or, less commonly now, stop-motion animation. Integrating special effects, 2D and 3D animation is known as compositing and is usually done before the final edit.

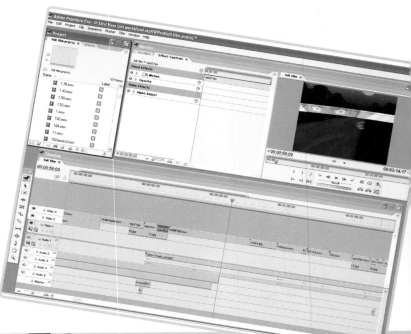

▶ **Motion blur** *Adobe's editing software, Premier, comes with filters for adding effects such as motion blurs to film sequences. Some Photoshop filters will work with Premiere. Effects added at this stage do not affect your original images, only the final output.*

114 SPECIAL EFFECTS

- Adding effects to your animation
- Using compositing to unify elements

Making fire

Animations are highly planned and created frame by frame, so the reliance on post-production effects is significantly reduced, but the integration of 2D and 3D within frames has become a fairly standard practice. Even studios such as Studio Ghibli, renowned for their highly detailed, hand-drawn animation, are utilizing more 3D for complex effects that would otherwise require a phenomenal amount of pen-and-ink work. For instance, it is very time-consuming to render the elements with traditional hand-drawn animation, in particular water, air, and fire, and their various manifestations, such as smoke and clouds. Of course, action and sci-fi require the now-obligatory explosions, and software assistance with these can be invaluable.

▲ **Working at the render stage** *Some 3D software gives you the option of adding motion blur to images at the render stage. This character was created in 3D and rendered with a toon-shader to make it look like 2D animation.*

Software links

Always check that software is suitable for your platform before you pay for it!
After Effects: **www.adobe.com/aftereffects**
Combustion: **www.autodesk.com/combustion**
Shake: **www.apple.com/shake**
Jahshaka: **www.jahshaka.org**

Compositing

3D packages, which are the staple of special effects, have been covered on the previous page. What you will need, though, is something to unify your 2D and 3D animation. Many of the pro-level 2D animation programs (Animo, Toonz, Harmony) are designed to import and work with 3D images but, like the pro 3D software, they come with a pro price tag and steep learning curve. To bridge this gap, compositing (often shortened to "comping") software is needed.

The basic function of the comping tool is to bring together all the different components that make up a frame or series of frames of your animation. In traditional cel animation, all the various elements are layered one on top of another and photographed as a single frame, and that is one of the principles behind these programs: building up layers to make a sequence. Combining the layering facility with a timeline gives you a lot of control over how you work with the different components. Add to this a host of filters for creating special effects, and these programs become an indispensable part of your software arsenal.

All manner of still and moving images, as well as audio files, can be placed into the comping program to build up a scene, which is then rendered into a unified sequence. It should be made clear that compositing software is not the same as an editing program. Although both applications share features and functions, in basic terms comping makes the individual sequences, while the editing software joins them all together.

It is possible to make your anime without comping or effects software, and when you are starting out you will probably have more time than money, anyway. Limited resources encourage creativity, but these tools will speed up your production cycle once the initial work is done.

Adobe After Effects is one of the best-known compositing programs, and for those familiar with other Adobe software it is reasonably easy to start using. Adobe also sells software bundles of their programs and their collection for video includes everything you need (Photoshop, Premiere, After Effects, and Audition) at a favorable price.

After Effects is a great, all-around tool for adding special effects to animations, especially those created with other Adobe products.

Programs to suit all budgets

Software such as Autodesk Combustion and Apple Shake are used by major Hollywood studios (Shake was used for *Lord of the Rings*) and have high hardware demands. For the anime artist with no budget, there is Jahshaka. This is an Open Source program for editing, animation, and special effects. It's free, but can be a little unstable; however, bugs get fixed very quickly. Its interface is a bit mundane and not very intuitive, but because it has plenty of tools in one place, for free, it is worth a look.

Compositing program in action

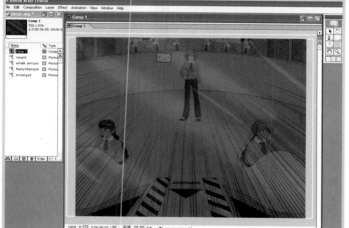

▲ Camera moves, colorizing, or using masks to create ripple effects like water are easily achieved through the use of layers, filters, and the timeline.

▲ All the elements, from various sources and media, are "comped" together using layers in After Effects. Each layer and element can have additional filters applied, if necessary.

Post-production is where you gather all the elements of your animation (animated sequences, voiceovers, sound effects, music) and bring them together. Adjustments can be made to the pacing and structure through editing. The post-production stage can be as long as the actual production, since this is your last chance to get it right before unleashing your vision on the public. Marketing and distribution are also part of this process, although you should have started thinking about this at the pre-production stage.

▲ *For Mac users, Final Cut (Express or Pro) is the best choice for editing and is fast becoming the default editing system for all filmmakers. It uses the familiar timeline format found in most editing programs.*

116 POST-PRODUCTION

▶ **Premiere** *This is the best option for editing for Windows users, as it comes with pro-level features and integrates perfectly with Photoshop. Like most digital video software, it uses a timeline for editing sequences.*

- **Editing it all together**
- **Mixing the final soundtrack**

Editing

Editing animation is different from live-action editing in that you are literally joining all the pieces together. None of the variables that exist with live-action are there with anime, as you are (or should be) in total control from the storyboard stage onwards. In animation there is only one take from a predetermined camera angle. 3D may offer more opportunities for exploration of camera views—but, once committed, rendering times make it impractical to "shoot" variable angles on a whim. The main purpose of editing is to ensure the movie has a good flow and rhythm to it, and the visual and audio elements all work together in harmony.

Editing software offers you multiple video and audio tracks to work with, depending on the package. It may be easier to mix all your sounds in a dedicated audio program, as long as it has video capabilities.

For very short animations, you may be able to do all the editing within the animation software, depending on the package, but most of them have limitations on the length of each scene and the number of audio tracks you can use. Long scenes also require more memory and rendering time. Editing software uses "aliases" of your rendered scenes, so that any cuts you make are non-destructive, which means it retains all the original material intact in case you change your mind later.

Editing programs offer a huge range of transitions, such as dissolves and fades, to go from one shot or scene to the next. These should be used as sparingly as possible or, better still, not at all. Ultimately, it is your decision, but it is a good idea to study other anime to see how often they are used and to what effect.

A digital recording studio can be easily set up for recording voiceovers and soundtracks, using your existing computer system.

Home recording studio

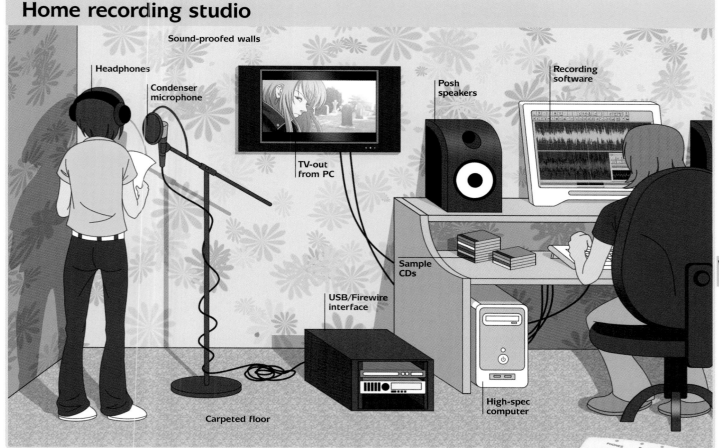

Sound-proofed walls

Headphones

Condenser microphone

TV-out from PC

Posh speakers

Recording software

Sample CDs

USB/Firewire interface

High-spec computer

Carpeted floor

For the record

Although sound (voiceovers and sound effects) have already been covered on page 78, they are very much part of the post-production process. In western animation the actors' voices are usually recorded before the animation starts, to give the animators something to work to and ensure accurate lip-synch. In anime it is far more common for the studios to add the voiceovers to a finished animation, allowing the actors to perform to the onscreen action. With more and more films being dubbed into multiple languages, the need for accurate lip-synch is no longer considered so important. Whichever order you record the vocals, doing it digitally is going to be the most advantageous method.

The main advantage of recording directly to your computer is that the files are immediately accessible to your editing software. In fact, most editing programs include the facility to record voice tracks. This is principally for adding voiceovers to documentaries, but that does not mean it cannot be used for animation. Ultimately it does not matter when you record the voiceover, as long as it works to your satisfaction.

▼ *An interface, such as this Tascam US-122, will allow you to connect mikes and musical instruments to your computer for making digital recordings.*

For voiceovers, a quality microphone is vital in getting the best possible recording, whether it is to disc or hard drive. Choose one specifically designed for studio voice recording.

Sound effects and music

Sound effects, whether you create and record them yourself or get them from sound effects libraries (online or CD), are best added during the editing process or even after the final edit is finished. This also goes for the music. Your composer may come up with some themes and ideas during the early stages of production, but to make the music really work it has to be produced to synch with the onscreen action. Some films have been edited to fit the score, but this is very rare, and usually when the composer and editor are the same person.

Using royalty-free music is one solution, but finding the right piece to fit your movie can be a long and arduous task, you have to pay a fee, and they rarely fit the mood and tempo of your movie. Programs like Apple's Garage Band or Soundtrack have pre-recorded loops of instruments and sounds that can be strung together to make original soundtracks, and are designed to work with editing software. The range and diversity of loops available cover just about everything you could need. It means you get an original score for no outlay.

Showtime

Once all the video and audio components are edited together, you will need to transfer the finished piece onto a medium that will allow you to show it to others. At present, DVD is the easiest and most accessible, but technology changes so fast that today's medium could be superseded in a year's time. High Definition (HD) is becoming the new standard, so it is advisable to start working in that format from the beginning. You can change HD into Standard Definition (SD), but not the other way around. An HD image will project perfectly in a suitably equipped cinema and be a match for anything shot on film. The chances of your movie being shown at your local multiplex are fairly slim, but with hundreds of film festivals around the world there is still plenty of opportunity for it to be seen on a big screen, and even an SD DVD can give a good image with the right projector.

Having your movie on DVD also means you can sell it to other people to watch on their televisions at home and, thanks to the power of the internet, the possibility of that happening is greatly improved. There are many websites, such as Atom Films, that will show all manner of short films. Alternatively, you can create your own website to show your work and sell DVDs, if you can get people to visit it. This is true independent moviemaking, which leaves you in control of your work, and any money you make is yours. If you find someone else to do the distribution for you, you will have to make some sacrifices in terms of revenue share, but 60 percent of something is better than 100 percent of nothing. The important thing is not to sign over the copyright of your work to anyone else, unless they offer you a serious amount of money—and even then you should think twice.

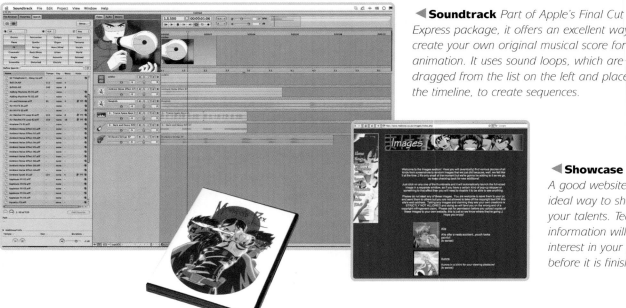

◀ **Soundtrack** *Part of Apple's Final Cut Express package, it offers an excellent way to create your own original musical score for your animation. It uses sound loops, which are dragged from the list on the left and placed in the timeline, to create sequences.*

◀ **Showcase it!** *A good website is the ideal way to showcase your talents. Teaser information will build interest in your project before it is finished.*

Websites, such as www.powerfx.com, are an excellent source of sound effects and music loops for your soundtrack. You can preview the sound before buying it and you only need to buy the ones you want, rather than a CD of redundant sounds.

Rights

In simple terms, you own the copyright to any original work that you create, unless and until you sign those rights over to another person or organization. It's then that the whole issue of rights becomes murky and filled with lots of legalities and jargon that seem mainly to benefit the lawyers.

You may not need to prove or defend the originality of your work while it remains in the non-profit realm of private showings, but the sooner you learn to protect yourself, the better—especially if you intend to post your work on the internet. Bone up on your legal options as early as possible in the production process.

Always check that software is suitable for your platform before you pay for it!

Music
Cubase: www.steinberg.de
Deck: www.bias-inc.com
Digital Performer: www.motu.com
Garage Band: www.apple.com/ilife
SoundForge: www.sonymedia.com
Tascam: www.tascam.com

Sound effects
www.sonymediasoftware.com
www.powerfx.com
www.sound-effects-library.com
www.soundoftheweb.com

Editing software
Avid: www.avid.com
Final Cut Express: www.apple.com/finalcut
Premiere: www.adobe.com/motion

Internet and Festivals:
www.withoutabox.com
www.atomfilms.com
www.amazefilms.com

No more excuses!

Whether you are thinking of showing your work at festivals or over the web is meaningless if you never actually get started. This book has given you all the basics you need to begin making your first digital anime. Any previous restrictions posed by a lack of equipment no longer exist. Computers are cheap and there is plenty of legally free software that can do the job if you can't afford to buy any. Just get started on bringing those ideas to life.

General anime books

The Anime Encyclopedia—Joanthan Clements and Helen McCarthy

Anime Explosion—Patrick Drazen

The Anime Companion—Gilles Poitras

Anime Essentials—Gilles Poitras

Watching Anime, Reading Manga—Fred Patten

Dreamland Japan—Frederik L. Schodt

Hayao Miyazaki—Helen McCarthy

Anime from Akira to Howl's Moving Castle—Susan Napier

Animation Art—Jerry Beck (Editor)

Japanese Comickers 1 & 2

Storytelling

Hero with a Thousand Faces—Joseph Campbell

The Writer's Journey—Christopher Vogler

On Writing—Stephen King

Worlds of Wonder—David Gerrold

Screenplay—Syd Field

General animation techniques

Cartoon Animation—Preston Blair

Illusion of Life—Frank Thomas and Ollie Johnston

The Animator's Guide to 2D Computer Animation—Hedley Griffin

The Animator's Survival Kit—Richard Williams

Timing for Animation—John Lasseter

Animation: The Mechanics of Motion—Chris Webster

General drawing/anatomy

Eadweard Muybridge—The Human Figure in Motion

Bridgman's Life Drawing—George Bridgman

Cartooning the Head and Figure—Jack Hamm

Anime and manga techniques

Anime mania—Christopher Hart

The Art of Drawing Anime—Ben Krefta

How to Draw Manga: (This is a multi-volume series of books by the Society for the Study of Manga Techniques that covers all aspects of manga and anime techniques).

How to Draw Anime and Game Characters—Tadashi Ozawa

Japanese culture

The Japanese Mind—Roger Davies

The Encyclopedia of Japanese Pop Culture—Mark Schilling

Everyday Japanese—Edward A Schwarz

The Japanese Have a Word for It—Boye Lafayette de Mente

Full Metal Apache—Takayuki Tatsumi

The Japanese Art of War—Thomas Cleary

Japan Unmasked—Boye Lafayette de Mente

Anime publishers/distributors

www.advfilms.com

www.an-entertainment.com

www.animetrax.com

www.bandai-ent.com

www.funimation.com

www.geneoanimation.com

www.ironcat.com

www.manga.com

www.media-blasters.com

www.rightstuf.com

www.tokyopop.com

www.urbanvision.com

www.viz.com

Anime drawing tutorials:

www.bakaneko.com

Online art communities

www.cgtalk.com

www.dream-grafix.be

www.gaiaonline.com

www.sweatdrop.com/forum

Internet and festivals:

www.amazefilms.com

www.atomfilms.com

www.withoutabox.com

Rights

While most countries automatically recognize copyright and intellectual property rights, it is a good idea to register your anime if you intend to distribute outside of your friends and family.

In the US: www.copyright.gov

In Australia: www.copyright.org.au/

Check this site out if you want to know more about the concept of "fair use": http://fairuse.stanford.edu/

Software:

Always remember to check that software is suitable for your platform before paying for it!

3DS Max: www.autodesk.com/3dsmax

Adobe photoshop: www.adobe.com

After Effects: www.adobe.com/aftereffects

Animation:Master: www.hash.com

Animation Stand: www.animationstand.com

Animo: www.animo.com

Carrara: www.daz3d.com/carrara

Cinema 4D: www.maxon.net

Combustion: www.autodesk.com/combustion

Corel Painter: www.corel.com

DAZ|Studio and Bryce: www.daz3d.com

Electric Image: www.eitechnologygroup.com

Flip Book: www.digicel.net

Jahshaka: www.jahshaka.org

Lightwave: www.newtek.com

Maya: www.autodesk.com/maya

Messiah: www.projectmessiah.com

Paint Shop Pro: www.jasc.com

Poser and Vue: www.e-frontier.com

Retas! Pro: www.retas.com

Soft Image: www.softimage.com

Solo: www.toonboom.com

Toonz: www.toonz.com

Shake: www.apple.com/shake

Editing software

Avid: www.avid.com

Final Cut Express: www.apple.com/finalcut

Premiere: www.adobe.com/motion

Further reading and links

GLOSSARY

Airbrush: A small, precision spray gun that runs on compressed air and uses inks to produce soft graduated colors. Also refers to the software tool that emulates the physical airbrush.

Animatic: A filmed, taped, or computer-animated version of the storyboard that runs the same length as the finished animation.

Anime: A Japanese-style animation. Sometimes called Japanimation, it is characterized by people with large, exaggerated round eyes.

Anti-aliasing: The process of resampling pixels to make hard, jagged edges look soft and smooth.

Background artist: The person who paints the background scenery of an animation.

Batch process: Setting the computer to perform a repetitive task to a large number of files; e.g., reducing all images to the same size

Bitmap: A text character or graphic image comprised of dots or pixels in a grid. Together, these pixels make up the image.

Blue screen: A background of pure blue (or green) that can be removed with compositing software and replaced with another image. Also known as Chroma-Key.

Broadband: A fast internet connection. For home computer users, this is usually either DSL or cable.

Camera stand: A support for a still or video camera. This can be a tripod, a copy stand, or a more sophisticated professional rig.

CD, CD-R, CD-RW: Compact Disc, Compact Disc Recordable, Compact Disc Rewritable.

Cel: A sheet of transparent cellulose acetate used as a medium for painting animation frames. It is transparent so that it can be laid over other cels and/or a painted background, then photographed.

Cel shading: Using flat color to simulate grauated tones. Gets its name from painting flat colors onto acetate sheets in traditional animation.

CGI (Computer Generated Imagery): Animated graphics produced by a computer. Also referred to as CG in the context of animation.

Character profile: Building a personality history of a story character to help make them appear more believable.

Character designer: Artist who creates the look of the individual characters.

Chibi (Super-deformed [SD]): A style of anime or manga where the characters resemble children and have very big eyes.

Clean-up: Retracing an animator's sketches into single, clearly defined lines.

CMYK: Cyan, magenta, yellow, and black—the standard inks used in four-color printing.

Compositing (also comping): Joining together the various layers and elements of an animation or special effect.

Continuous tone: Where there is no discernible line between different shades of a color, such as in a photograph.

Copyright: An artist's legal right to control the use and reproduction of his or her work. In some countries it is seen as the right to copy.

Cross-hatching: Two groups of parallel lines that are drawn close together across each other, usually at an angle of 90°, to show differences of light and darkness.

Digital ink and paint: The process of tracing and coloring an animator's drawings using a computer.

Director: Creative supervisor for an entire animation, who decides everything from camera angles to the musical score.

Dope sheet: see Exposure sheet.

Doubles: Shooting on doubles or twos is the process of photographing two frames of a single image, either as a cel or 3D model.

Dubbing: Adding extra sounds on top of other sounds; replacing one language dialogue with another language; copying from one tape to another.

Dutch angle: Tilting the camera sideways for a shot so the horizon is on an angle.

DV: Digital Video.

DVD (Digital Versatile Disc): A disc capable of holding a large amount of data. Principally used for films.

Editing: Putting all the various shots and elements of the movie together into a coherent whole.

Exposure sheet: A form onto which all the shooting and drawing information for an animation is entered, one frame at a time.

Fan art: Pictures of established characters interpreted and created by readers/viewers and fans.

Field guide: A punched sheet of heavy acetate printed to indicate the sizes of all standard fields. When placed over an artwork, it indicates the area in which the action will take place.

Filter: A piece of glass or plastic that goes over the lens and changes the color and/or the amount of light reaching the film or tape. Software filters serve a similar function. They can also apply special effects.

FireWire: A high-speed connector used to download digital data at extremely high speeds from peripherals (such as DV cameras, hard drives, and audio hardware) to a computer. Also known as IEEE1394 and i-Link.

Flash: A Macromedia program for creating vector-based animation for the internet. Its .swf format is the default standard.

Flip book: Simple animation made by drawing a series of images on the pages of a book and flipping the pages with one's thumb to make the characters or design appear to move.

Frame: An individual photograph on a strip of film. When the film is projected, each film is normally seen for one twenty-fourth of a second, or at a frame rate of 24fps (frames per second). However, the fps varies according to final format; e.g., Film—24fps, PAL video—25 fps, NTSC video—29.97 or 30 fps.

Game play: The storyline and interactive parts of a computer game.

GIF (Graphics Interchange Format): A computer image format used on the internet for images with fewer than 256 colors. Good for bold graphics.

Graphics tablet: A computer peripheral that allows you to draw or write using a pen-like instrument as if you were working on paper.

Graticule: see Field guide.

Gray scale: Black-and-white image with full tonal range of grays.

HD (high definition): Generally refers to equipment used to create and process content for use with HD television sets, DVDs, or movie projectors. HD simply means that there are a greater number of lines of resolution in an image than on a traditional (SD) image.

Inking: Tracing a cleaned-up drawing onto the front of a cel for painting.

Jaggies: Hard-edged pixels that appear on computer-generated lines when they are not anti-aliased.

JavaScript: Platform-independent computer language developed by Sun Microsystems. Mostly used for adding interactive effects to web pages.

JPEG (Joint Photographic Experts Group): A universal format for storing digital image files so that they take up less space.

Keyframe: Frame that shows the extreme position of an action or a principal movement in an animation.

Layers: Cels comprising different elements of a single frame and mounted one on top of the other. Also simulated in software programs.

Layout artist: The person who designs the composition of the shots.

Lead animator: Person in charge of the animation team. Usually draws keyframe action.

Lightbox: A glass-topped box with a powerful light source. Used by animators to trace artwork.

Line animation: Animation created with drawings.

Lip synch: The matching of characters' mouth shapes in time with recorded dialogue.

Live action: Film made using real people or actors.

Manga: Japanese printed comics.

Maquette: A small statue of a character used as a drawing or 3D modeling aid.

Medium (pl. media): Material onto which you movie will be shot or stored; film, DVD, videotape.

Megapixel: 1,000 pixels. Used to describe the resolution of digital cameras.

MIDI (Musical Instrument Digital Interface): An industry standard for connecting synthesizers to computers in order to sequence and record them.

MoCap (Motion Capture): A way of capturing accurate human movement for use in 3D software by attaching sensors to an actor and mapping the coordinates in a computer program.

Model sheet: A reference sheet for the use of animators to ensure that a character has a consistent appearance throughout a film. It consists of a series of drawings showing how a character appears in relation to other characters and objects, with details of how it appears from various angles and with different expressions.

NTSC: Television and video format used in the U.S. and Canada (480 vertical lines of resolution).

OAV (original animation video): Also known as OVA (original video animation), this refers to anime released straight to DVD, without first being shown on TV or in cinemas. This affords the maker greater creative freedom and time than TV would allow, without the costs of a theater release.

Onion-skinning: The ability to see through to underlying layers of drawings for tracing and comparing images when tweening.

OS (Operating System): The part of a computer that enables software to interface with computer hardware. Two commonly used operating systems are Microsoft Windows and MacOS. Others include UNIX, Linux, and IRIX.

PAL: Television and video format used in Europe, Australia, and Asia (576 vertical lines of resolution).

Panning shot: A shot that is achieved by following an action or scene with a moving camera from a fixed position.

Peg bar: A metal or plastic device to hold hole-punched paper and cels so that they remain in register.

Peripheral: An external device attached to a computer to add extra functionality.

Phoneme: Phonetic sounds used in speech to help the animator make the correct mouth shapes (visemes) for lip synching.

Pixel (from PICture ELement): The smallest unit of a digital image. Mainly square in shape, a pixel is one of a multitude of squares of colored light that together form a photographic image.

Pixellation: A stop-motion technique in which objects and live actors are photographed frame by frame to achieve unusual motion effects.

Plug-in: A piece of software that adds extra features or functions to another program.

Pre-production: The planning stage of an animation.

Primitives: Basic shapes used by 3D software (cube, sphere, cylinder, cone).

Protagonist: The lead character in a story.

QuickTime: A computer video format developed by Apple Computer.

QTVR (QuickTime Virtual Reality): A component of QuickTime, used for creating and viewing interactive 360-degree vistas on a computer and on the Web.

RAM (Random Access Memory): The area of computer memory where the computer holds data immediately before and after processing, and before the computation is written to disc.

Raytracing: Used by a rendering engine to create an image by sending virtual rays of light from the light sources so they reflect off the objects in a scene.

Registration: The exact alignment of various levels of artwork in precise relation to each other.

Render: To create a 2D image or animation from 3D information.

RGB (Red, Green, Blue): The colors used in computer and TV monitors to make all the colors we see on screen.

Rostrum camera: A motion-picture camera that can be mounted on columns and suspended directly over the artwork to be filmed.

Rotoscope: A device that projects live-action film, one frame at a time, onto a glass surface below. When drawing paper is placed over the glass, the animator can trace off the live-action images in order to get realistic movement.

Scanner: Computer peripheral for transferring printed images into the computer.

Script (also Screenplay): The dialogue and directions of a film.

Showreel: A portfolio of moving images on videotape, DVD, or CD.

SD (standard definition): Refers to the traditional resolution (490 vertical lines on a TV set, or 2000 lines on a theater screen). Is now being replaced by HD

Steadicam: A camera rig that is harnessed to a steadicam operator so s/he can follow actors in a scene without the camera jolting.

Stop Action or Stop Motion: Animation where a model is moved incrementally and photographed one frame at a time.

Story reel: see Animatic.

Storyboard: A series of small consecutive drawings plotting key movements in an animation narrative, and accompanied by caption-like descriptions of the action and sound.

Streaming video: A sequence of moving images s0ent in compressed form over the internet and displayed by the viewer as they arrive. The Internet user does not have to wait to download a large file before seeing the video.

Stylus: A pen-shaped input device for a computer that is used in conjunction with a graphics tablet.

Texture map: 2D image used to give texture to a 3D object.

Timeline: Part of software that displays the events and items of an animation in terms of time or frames.

Toon shading: See cel shading.

Trace back: Sometimes a part of an animation may remain unchanged from one cel to the next. It is therefore traced back onto subsequent cels.

Track (or truck): A cinematic shot where the camera moves through a scene.

Tweening: Drawing the intermediate drawings/frames that fall between the keyframes in an animation.

Vector: Lines created in computers using mathematical equations.

Vector animation: An animation that uses images created with vectors. Vector animations are resolution independent so they can be enlarged to any size without deterioration of image quality.

Vertex: A control point on a 3D object, where two lines of a wireframe model meet.

Visemes: Mouth shapes corresponding to phonemes.

Wireframe: A representation of a 3D object showing its structure made up of lines and vertices.

Worldwide web: The graphical interface of the internet that is viewed on a computer using a software browser.

INDEX

Quarto would like to thank and acknowledge the following for supplying images reproduced in this book:

Key: l left, r right, c center, t top, b bottom

4, 41, 43, 44tl, 44b	Wing Yun Mann www.ciel-art.com
7b	Gavin Dixon www.photographersdirect.com
8	2000 Pikachu Projects/The Kobal Collection
9t, 11t, 36t	Simon Valderrama
9c, 9b, 17tl, 17tr, 17br	Kjeld Duits www.ikjeld.com
11cr	MGM/Corbis
11b	Mick Hutson/Redferns
12, 14t, 80	Hayden Scott-Baron www.deadpanda.com
15t, 81, 106b	Selina Dean www.noddingcat.net
16t, 19c, 110b, 111t	Rik Nicol www.wooti.net
18b, 19b, 84b, 109b	Helen Smith www.makenai.co.uk
18r	Emma Vieceli www.emma.sweatdrop.com
19t	Viviane www.viviane.ch
22	Tezuka Productions Co., Ltd./Mushi Production Co., Ltd.
23b	Tezuka Productions Co., Ltd.
31	The Art Archive/Claude Debussy Centre St Germain en Laye/Dagli Orti
44bl, 45t	Patrick Warren
40t, 44tr, 45b	Cosmo White
42, 44r	Paul Duffield
106t	Two Animators! www.twoanimators.com
117bl	Samson Technologies

We are also indebted to Manga Entertainment Ltd for kind permission of the following:

6c, 10cl, 16cr, 21b, 23t	AKIRA © 1987 Akira Committee. Produced by AKIRA COMMITTEE/KODANSHA. Licensed by Kodansha Ltd. All Rights Reserved
6b, 10cr, 10b, 16cl, 16b	GHOST IN THE SHELL: STAND ALONE COMPLEX © 2002-2006 Shirow Masamune-Production I.G/KODANSHA. All Rights Reserved
10t, 14b, 15b, 17b, 85bl	GHOST IN THE SHELL © 1995 Masamune Shirow/Kodansha Ltd./Bandai Visual Co. Ltd/ Manga Entertainment Ltd. All Rights Reserved